the quick & easy guide to
photographing your artwork

the quick & easy guide to
photographing your artwork

Roger Saddington

NORTH LIGHT BOOKS
Cincinnati, Ohio
www.artistsnetwork.com

Roger Saddington is a prominent Australian artist, designer and educator. After graduating from the National School of Design at Swinburne University in 1991, Saddington worked in graphic design for most of the 1990s. He served a five-year tenure as senior designer at the National Gallery of Victoria in Australia. During this time he supervised the reproduction of artwork for major retrospectives of Rembrandt, van Gogh and Matisse and designed graphics for significant international artists such as Mike and Doug Starn.

Saddington then spent several years developing a unique, semiabstract landscape painting style and exhibiting at prominent galleries in Melbourne and Sydney. His work is held in private collections in the United States, England and Australia. He has won several awards, including the Southern Cross Design Award and the Margery Withers Drawing Scholarship.

Saddington currently serves as head of image studies at Swinburne University in Melbourne. He also continues to paint and photograph the landscape and exhibit regularly. He is largely self-taught as a photographer.

Other fine North Light Books are available from your local bookstore or art supply store or direct from the publisher.

07 06 05 04 03 5 4 3 2 1

Library of Congress Cataloging-in-Publication Data
Saddington, Roger,
 The quick & easy guide to photographing your artwork / Roger Saddington.
 p. cm.
 Includes index.
 ISBN 1-58180-283-8 (pbk. : alk.paper)
 1. Photography of art. I. Title: Quick and easy guide to photographing your artwork. II. Title.

TR657 .S24 2003
778.9'97—dc21

 2002032136

Edited by Amanda Metcalf
Cover designed by Wendy Dunning
Interior designed by Angela Wilcox
Production coordinated by Mark Griffin

The permissions on pages 110 and 111 constitute an extension of this copyright page.

METRIC CONVERSION CHART		
TO CONVERT	**TO**	**MULTIPLY BY**
Inches	Centimeters	2.54
Centimeters	Inches	0.4
Feet	Centimeters	30.5
Centimeters	Feet	0.03
Yards	Meters	0.9
Meters	Yards	1.1
Sq. Inches	Sq. Centimeters	6.45
Sq. Centimeters	Sq. Inches	0.16
Sq. Feet	Sq. Meters	0.09
Sq. Meters	Sq. Feet	10.8
Sq. Yards	Sq. Meters	0.8
Sq. Meters	Sq. Yards	1.2
Pounds	Kilograms	0.45
Kilograms	Pounds	2.2
Ounces	Grams	28.3
Grams	Ounces	0.035

To Lisa, my inspiration

The list of people who saw the immediate potential for this project is rather small. This fact makes the foresight of those who did all the more extraordinary. *The Quick & Easy Guide to Photographing Your Artwork* was conceived at a difficult time for me personally, and in this sense those who encouraged me along the way contributed directly to the book's very existence. Profound thanks and love go to Lisa Chapman in this and every other regard.

I am extremely grateful for the conspicuous goodwill and enthusiasm of David Crofts, Gina Panebianco, Hugo Leschen and Steve Rassmussen. Thanks also to Helen Skuse, whose keen eye was invaluable in honing the technical detail of the manuscript.

Many thanks to Pam Wissman for overseeing my induction into the North Light Books stable. Her fundamental contribution to the logical flow and user-friendliness of this book transformed the manuscript into a fully functional resource. My gratitude also goes out to Amanda Metcalf, whose friendly but thorough guidance has been greatly appreciated. It has been a pleasure to work with such a professional organization.

The artists whose work appears in this book deserve special thanks. Many went out of their way to assist with the process, and I am very pleased to see their work in print.

One small act of kindness can reverberate beyond the original intention. I thank Beryl Clinton for giving me my first SLR camera when I was twelve.

Finally, but perhaps most importantly, I would like to thank my father, John Saddington, whose dignity and patience I hope one day to acquire.

Table of contents

CHAPTER ONE

Cameras, Lights and Accessories

Identify the camera you own and

learn what camera and equipment

work best for the artwork photogra-

pher. Learn about the various kinds of

light, the film that works in each set-

ting and the surprisingly simple

equipment that will get the job done

CHAPTER TWO

Setting Up Your Studio

Set up a photography studio to

photograph either two-dimensional

or three-dimensional art

CHAPTER THREE

Taking the
Picture

Master the steps to taking

a perfect picture

58

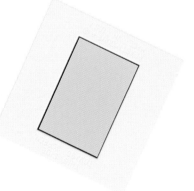

CHAPTER FOUR

Troubleshooting

So something went wrong with your

pictures and you're not quite sure

what it is. You'll find it here, along

with tips for photographing artwork

with metallic paint and artwork in

galleries and exhibitions

74

Introduction

Because you've picked up this book, you probably already have a specific reason to photograph art. As an artist or student, you may want to approach galleries for an exhibition, to document your collection or to send samples of your work to potential clients. *The Quick & Easy Guide to Photographing Your Artwork* offers easy, inexpensive ways to create quality photographs to achieve these goals.

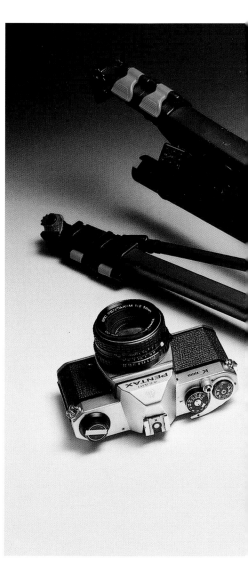

For most artists, photographing artwork is a necessary evil, a difficult and expensive process that takes their minds and their money away from creating art. This need not be the case. Though the photography process may seem unpredictable and mysterious, read on, and you can quickly learn to tame the tiger.

Cameras and film are constants in the photography equation. They behave the same way every time you use them. It's the conditions—the lighting and your setup—that act as the variables. Artists seldom photograph their work under controlled conditions. Thus the results vary widely. With a little know-how, you can easily create the correct conditions for photographing artwork. By reading this book and following the simple instructions carefully, you soon will feel confident in your ability to create a mini photography studio wherever you like. The object of this book is to give clear, concise instructions for accurately photographing artwork—to get on with the practical side of photography without too much theory.

The methods in this book are the products of a combination of common practice and common sense, with the latter prevailing. I've modified professional photography techniques here to make them compatible with artists and their bank account balances. Forget what you already know about photography, including notions of what makes a good camera and what sort of lighting is right for the job. All will be revealed, and some of the suggestions might surprise you.

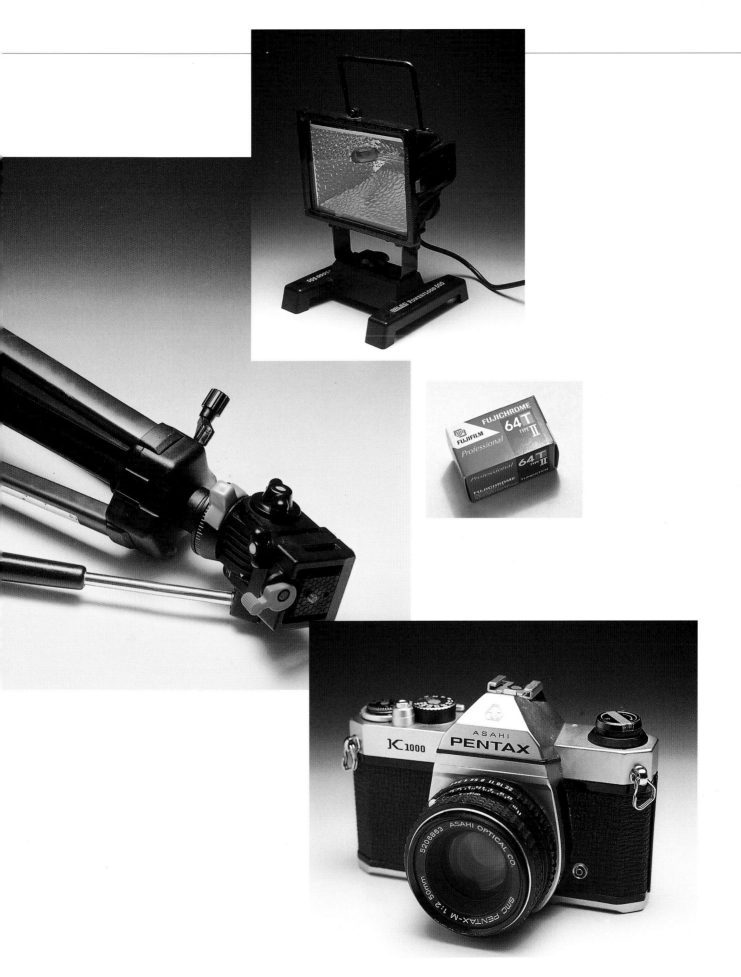

A basic lesson in photography

The camera is merely a simple tool for taking pictures. Any camera, whether an early box version or the latest high-tech model, is fundamentally a box we use to protect film from light until the moment we are ready to take a shot.

All cameras work on the simple principles in the sidebar at right. The only thing that varies is the amount of automation particular models use. Don't let camera salespeople or professional photographers bamboozle you with jargon and gadgets that make you think you need a degree to take professional-quality photos or that the camera will do everything for you. Neither of these scenarios is correct. Some cameras will measure the light and make decisions for you. Others will tell you the amount of light present, leaving you to set the controls yourself. Either way, it's up to you to ensure the quality of your results. Don't worry, though; the process is surprisingly simple.

Almost all cameras can be used to photograph artwork, though some are more convenient than others when aiming for professional results. Don't rule out a camera as suitable for artwork photography because it's old or just a basic camera. Basic cameras can work particularly well, and many professional photographers use older models known to be well-engineered. Chapter one will help you decide which type of camera you have and how it's likely to perform.

Using the knowledge you gain from this book, try to simplify every aspect of photography. Cameras, film, lighting and film processing aren't that complicated if you know what results you're after. Purveyors of these goods and services will dazzle you with all kinds of technical language if you let them. Don't pretend to know more than you do. Tell them you're not a professional photographer, and use your own words to explain what you want. Have the confidence to talk with professional photography suppliers in your language instead of theirs.

Most importantly, know the rules before you break them. Follow the instructions in this book exactly to ensure top-quality results. The process has been carefully designed to be foolproof, and you should experiment only after you've mastered the process as written here. To make sure you understand each step in full, read the whole book before you start. When it's time to photograph your artwork, you can work quickly and confidently and be assured of the results you want.

PHOTOGRAPHY IN A NUTSHELL

1. Light passes through the **aperture**. The size of the aperture controls how much light hits the film.
2. The **lens** controls the size and focus of the image passing through the aperture.
3. A **shutter** covers the aperture and opens for a fraction of a second when you press the button, allowing light to reach the film via the lens and aperture. The amount of time the shutter is open, the **shutter speed**, controls how long light hits the film.
4. The total amount of light striking the film, as controlled by the aperture and shutter speed, is called the **exposure**.
5. View the image you are about to photograph through the **viewfinder**.

film winding lever

lens

focus ring aperture ring

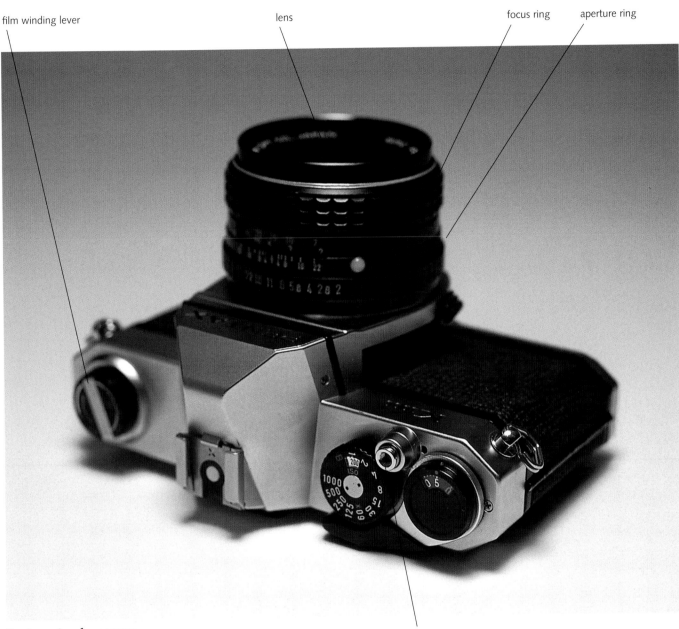

shutter release

Basic parts of a camera

Light enters the camera through the lens. Use the focus ring to bring
the image into focus. Use the aperture ring to control the amount of
light that enters the camera. Press the shutter release to open the shut-
ter and allow light to hit the film. Use the film winding lever to advance
to the next frame on your film and start over again!

Cameras, Lights and Accessories

Is your camera suitable for artwork photography? You'll be pleased to know that most are. If you already own a camera, use this chapter to identify what kind you have. If you don't have a camera, think about whether you know anyone who does. If you can't borrow, you may have to buy. A little homework can be surprisingly cost effective. Following is a guide to the basic types of cameras.

Manual camera

The best camera an artist can use to photograph his or her own artwork is a 35mm single-lens reflex (SLR) manual camera.

Manual cameras measure the light falling on a subject and let you set the controls accordingly. Automatic cameras, in contrast, measure the light and set the controls for you. Because manual cameras let you set the aperture and shutter speed yourself, it's easier to set manual cameras to take photographs true to your art. Fully automatic cameras also will work, though they're not quite as convenient for artwork photography. If your automatic camera has a manual setting, set it on manual and treat your camera like a manual camera for the rest of the book.

A 35mm format, which refers to the size of the film the camera takes, works well for simply establishing a record of your artwork on film and for showing it on a slide projector. 35mm slides are also the preferred product for most art gallery proposals, publishing proposals, grant applications and folio presentations. Transparencies, such as slides, are translucent, so you can view the image by letting light shine through the back. Photographic prints, in contrast, are printed on solid paper. If you need larger transparencies than 35mm slides, such as 4" × 5" (10cm × 13cm) or 8" × 10" (20cm × 25cm), have a professional photographer take them.

The single-lens reflex can be manual, automatic or both and is the best choice for the average artist.

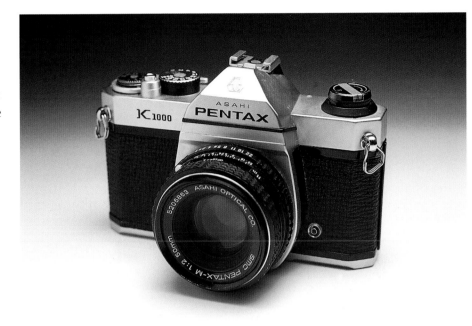

Single-lens reflex camera
Also known as SLRs, these have one lens on the front. Most have a series of rings along the lens barrel to control the focus and aperture.

DEFINITIONS

automatic camera—a camera that chooses settings, such as the size of the aperture and the shutter speed, on its own

manual camera—a camera that allows the photographer to control the settings

single-lens reflex—a camera with one lens through which the photographer looks at the image and takes the picture. Other cameras have a viewfinder separate from the lens so the photographer views the scene from a slightly different perspective than the film views it.

Automatic, compact and digital cameras

You also can use an automatic camera. Some automatic cameras, aperture priority and shutter priority automatics, allow you to override the settings the camera took automatically. A fully automatic camera requires you to trick it into exposing some artworks correctly. Refer to your camera's instruction manual or talk to someone at your local camera store if you're unsure whether your camera is manual or automatic.

Compact cameras, unlike single-lens reflex cameras, have two lenses. If you have a compact camera, make sure it can take 35mm film. Slide film comes in 35mm format, and smaller film just won't produce quality photographic prints.

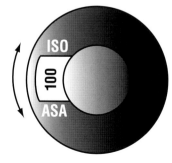

Compact camera

Compact cameras, also known as viewfinder cameras, APS (advanced photo system) cameras or Instamatic cameras, have two lenses on the front. The photographer views the subject through one lens and photographs it through another. The average consumer owns an automatic compact.

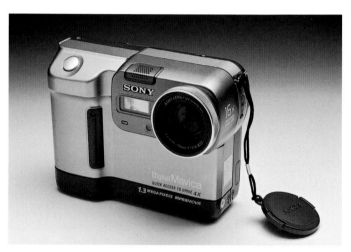

Digital camera

Digital photography is a relatively new innovation. Digital cameras, which conveniently operate without film, have become very popular. Despite the convenience, though, digital cameras for the amateur market just aren't ready for artwork photography. If you do want to spend the money on a professional-level digital camera, you'll need a computer; a printer; a good program that can adjust contrast, brightness and color balance; and plenty of patience to get the best results. Conventional cameras and film are easier to adapt to the demands of artwork photography.

Getting an accurate exposure

Very light or very dark artwork will confuse the camera's light meter and cause it to overexpose or underexpose an image. To trick the camera into taking a photo that accurately captures the colors and values in your artwork, you'll have have to adjust the way the camera plans to expose the film. Most automatic cameras automatically recognize the film speed rating, of each roll of film. Look for a film speed dial (left) on your automatic camera. You can manipulate the exposure by setting this dial to a different film speed than the film you've loaded. If you don't have a film speed dial, you can manipulate the exposure with an exposure compensation dial.

Shopping for the right camera

If you don't have a camera and can't borrow one suitable for artwork photography, it's time to go shopping.

What you really need

To get photographs true to your artwork in color and accuracy, the qualities you really need are:

1. a camera that takes 35mm film
2. an SLR or compact model
3. a manual or automatic camera with manual override
4. a 50mm standard lens or a zoom lens that includes 50mm within its range
5. TTL (through-the-lens) metering
6. a major brand such as Pentax, Olympus, Nikon or Canon. The quality of equipment by these and other long-standing manufacturers has been tested in the field by professional photographers, so you know these cameras can get the job done. You'll also be able to find parts for these big-name cameras easily if you need to repair them.

Consider secondhand

Don't assume you need to rush out and buy the newest, most advanced, automated wonder machine. Most 35mm SLR cameras made after the 1960s have everything you need. Older cameras are the choice for artists on a budget. For the price of a new 35mm SLR model with automatic everything, you can buy a simpler, older, 35mm manual camera for artwork

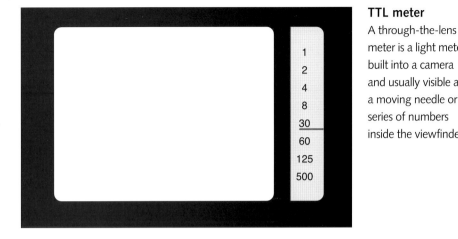

TTL meter
A through-the-lens meter is a light meter built into a camera and usually visible as a moving needle or series of numbers inside the viewfinder.

photography and an automatic compact for everyday snapshots.

Cameras are changing constantly with new models coming out each year. These constant upgrades have created a lively market for secondhand cameras. Use this to your advantage, and capitalize on the bargain to be had on last year's model.

Also be wary of manufacturers' warranties as an incentive to buy a brand-new camera. New cameras can fail the day after your warranty expires, adding a repair bill to the exorbitant new price. Even if something goes wrong with a secondhand purchase, the total cost of camera and repairs probably will be below the purchase price of a new camera.

Look for a professional photography shop where you can find plenty of secondhand photography gear. Such stores often have the simplest, most no-nonsense machines, and the staffs are knowledgeable and can help

artists on a budget. Check the phone book or ask a professional photographer for help finding these stores.

Comparison shop

When shopping for a car, you know that the engine itself will work the same whether you buy the base model or the deluxe model with a sunroof and power locks. Cameras work the same way.

Once you find a camera that fits your needs, look around for a similar model without a lot of unnecessary gadgets. Major brands' older models have engineering and optics that are every bit as good as modern versions for a much lower price.

Check to make sure you're being charged the market rate for the model you've chosen. Ask staff at secondhand dealers and amateur photography stores and check the Internet, catalogs and classifieds.

Inspect before you buy

When you're ready to buy, check both the focus and aperture rings by rotating them back and forth. The focus ring should move smoothly, not too loosely or too tightly for comfortable movement. Also make sure you can't dislodge it from its setting too easily. The aperture ring should move easily, clicking into place. Check both rings individually to make sure they're not loose and don't sound gritty when you rotate them. If so, the camera is worn from overuse.

Look through the front glass of the lens to check for dust, dirt or moisture inside. Remove the lens and inspect for rust, grit and excessive wear on the flanges that hold the lens in place.

Inspect the lens glass at both ends for scratches, bubbles and other marks. One or two minor scratches on the glass shouldn't be a problem, particularly if the price is right, but beware of deep, long scratches or lots of tiny ones. Hold the glass so light strikes it from different angles so you can spot any scratches. Scratches on the lens won't appear on your shots, but serious scratches or many little ones will keep the image from traveling through the lens to the film smoothly, affecting the general sharpness of the image.

Crank the film winding lever and depress the shutter release button, listening for strange noises or disjointed movement. Open the back of the camera and inspect the film housing. Make sure the fabric blind that covers the shutter in the center of the camera is in good condition without marks or holes.

Look for signs of wear inside and outside the camera itself. Dents and scratches on the camera casing are not necessarily a problem, although they may indicate years of poor treatment or constant use. Cameras from major brands are made to exacting standards, and most with regular servicing can take a moderate amount of rough treatment. Find out exactly what service the seller has done to prepare the camera for sale.

film winding lever lens focus ring aperture ring fabric blind

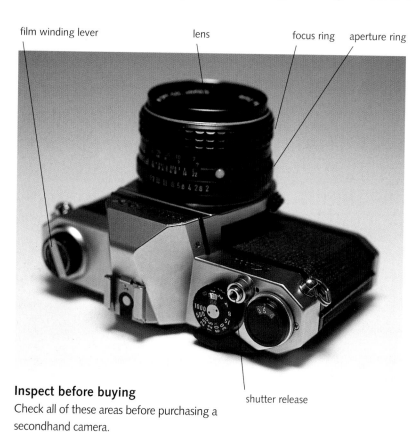

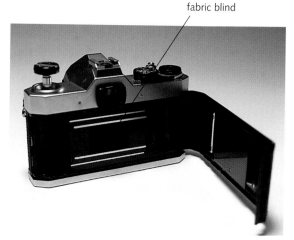

Inspect before buying
Check all of these areas before purchasing a secondhand camera.

shutter release

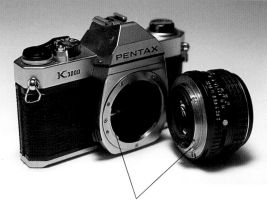

lens flanges

Tripods

You need a stable support for the camera to get quality photographs. Without it, your pictures will be blurry because the camera will move as you press the shutter release button. The most common support is a tripod, and the column tripod is the best choice for an artist.

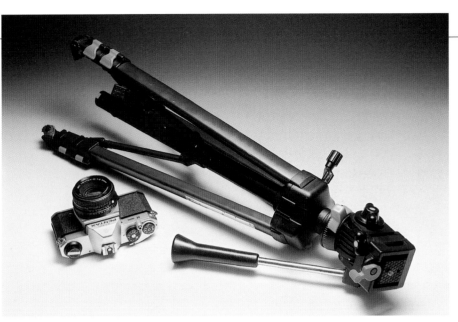

Column tripod

This is the best tripod for artwork photography because it mimics the features of larger, professional studio models. Column tripods have sturdy legs and a central column. You'll mount the camera on either a ball-and-socket head (left) or a pan-and-tilt head (below) that sits on the top of this central column. You can make slight height adjustments by moving the column up and down and bigger adjustments by changing the height of the legs. The best column tripods also have support braces running between the legs for extra stability.

Ball-and-socket head

A head holds the camera in place on the tripod. A ball-and-socket head swivels around a ball a bit smaller than a golf ball for easy and quick movement.

DEFINITION

support—any item, including a tripod, that will balance a camera at the right height and angle

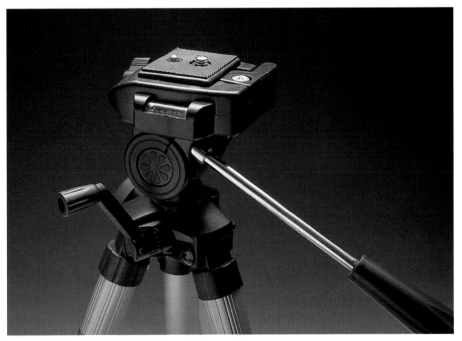

Pan-and-tilt head

The pan-and-tilt head allows the camera to tilt backward and forward and to pan from side to side as a video camera pans across a scene. Also look for a lateral adjustment facility that lets you turn the camera 90 degrees to take vertical shots. I prefer the pan-and-tilt head because it allows me to swivel from side to side without changing the tilt and to adjust the tilt without swiveling the camera.

Alternative tripods and supports

If you'll use your tripod for anything other than artwork photography, you may want to check out some alternatives. Travel tripods, for example, are easier to transport, and a tripod with a boom is great to take along hiking. If you want a more economic option, consider these other supports.

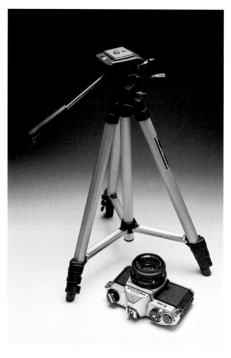

Travel tripod

These are similar to column tripods but smaller and lighter. Most travel models come with a simple pan-and-tilt head and are relatively inexpensive. Make sure you inspect it carefully before buying one. Extend the legs fully to make sure the column and legs adjust easily.

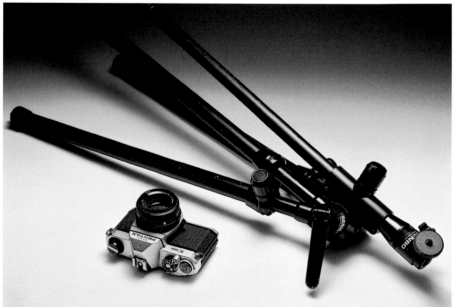

Tripod with a boom

The boom tripod works well in wilderness and other locations with uneven ground. The boom is an extension that allows you to position the camera away from the tripod and legs. While hiking, for instance, you can set the tripod on even ground and then extend the boom over less stable ground to get a better angle, and by tilting the boom and camera to face the floor, you can photograph objects on the ground without the tripod legs getting in the way. When the boom is fully extended, though, boom tripods can be a bit wobbly; let the tripod settle for a few seconds between making an adjustment and taking a picture.

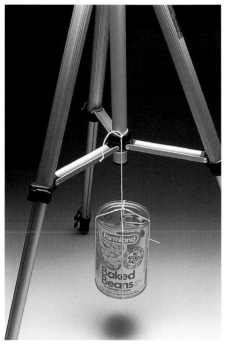

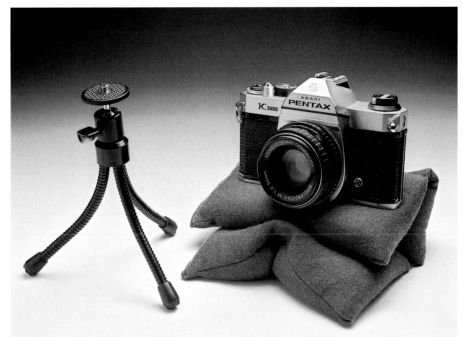

Stabilize a light tripod

The travel tripod's light weight provides less stability than the column tripod. If you bump the tripod accidentally, you'll have to line up the shot all over again. To avoid this, stabilize the tripod, using heavy-duty tape to attach it to the floor. You also can suspend a small, fairly heavy object from the bottom of the central column, but don't use an object that is too heavy. The purpose is not to strain the legs to the breaking point, but merely to make sure they're firmly planted.

Supports

Any device that holds the camera steady at the moment you take the picture will work as a support. You can even just tape the camera to a chair or small table. Make sure not to damage film spool buttons on the bottoms of most cameras. You also can tape the camera to a heavy book or other stable object with double-sided tape. Then you can set this object on any chair, table, stack of books or any other surface that reaches the height you need. Also try placing the camera on a small wheat bag or using a table tripod.

Accessories

These accessories will help you care for your equipment so it will last and produce the best possible pictures.

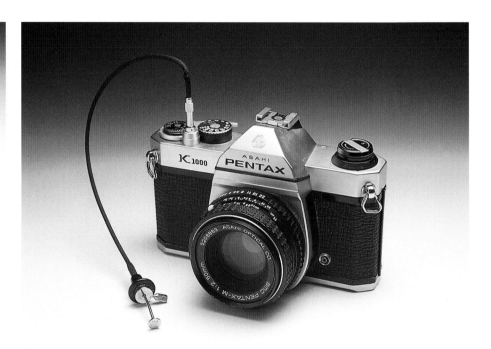

Lens cleaning fluid

Use lens cleaning fluid to remove dust and fingerprints when necessary. Pour the cleanser on a wipe or cloth, not directly onto the lens.

Cable release

Camera shake at the moment of exposure is a common problem that renders blurry shots. A cable release allows you to take a picture without touching the camera and thus shaking it.

Blower brush

Use a small blower brush to keep the lens and camera housing clean. A camera undergoing regular use also should be serviced every few years.

The importance of light

Film doesn't see light the same way we do. Normal daylight film, which we use when we take a normal snapshot, is sensitive to all kinds of subtle changes in the color of light that we don't even notice. And when most artists photograph artwork, they assume that the daylight streaming in through the window is adequate light for the task. But our brains constantly make adjustments to the light we see, so you may not notice a small change in lighting conditions that will make a big difference in a photograph. To guarantee accurate photographs, you need to create consistent lighting conditions for your photo shoots.

Natural light just doesn't provide the accuracy and predictability you need. It changes color constantly because of the different amounts of atmosphere it passes through at different times of the day. Weather-related effects, such as clouds, mist, rain and a host of other atmospheric phenomena, are even more troublesome. Strange color casts that you can't see because your eyes have adjusted will show up in photographs of your artwork.

Charge
Roger Saddington
Acrylic on canvas
36" × 48" (91cm × 122cm)

Seeing light accurately

Waiting for the right outdoor conditions in which to photograph artwork can be extremely inconvenient, and when optimum conditions do occur, they can disappear again quickly. Compare the photograph of this painting in controlled lighting (top left) to photographs taken outside in the shade (top right), outside in direct sun (bottom left) and inside on a sunny day (bottom right). Notice that the background in each photo looks normal to your eyes, yet the color of the painting itself varies drastically in each shot. The key to artwork photography is taking accurate shots true to your artwork.

Tungsten lighting

To reproduce artwork, you have to eliminate variables and create a constant environment so your photos meet a uniform standard. Artificial light, because of its predictability, will do the trick better than natural light.

Tungsten light

Use tungsten light to illuminate your art evenly. Tungsten is a metallic substance that produces a broad beam of light. It's also used in household lightbulbs. Tungsten light does appear yellowish orange on daylight film, but because this result is predictable, you can compensate for it in your photos.

Tungsten-balanced slide film is balanced to see tungsten light as neutral and will correct the yellowish orange tone of the tungsten light. This film is not made for taking pictures in daylight, though.

When photographing to make prints instead of slides, just use normal daylight film, tungsten lighting and an 80B blue filter on the lens to rebalance the film for tungsten lighting. You can find filters at a professional photography store. Take your lens to make sure you get the right size filter.

Balancing film for tungsten light
Use tungsten-balanced film for slides and an 80B blue filter with daylight film for prints.

DEFINITIONS

80B blue filter—a filter for the camera lens, used with daylight film, that compensates for tungsten light's yellow-orange color

print—a photograph printed on photographic paper like a normal snapshot as opposed to a transparent slide

Tungsten-balanced film
The painting at top was photographed under tungsten lighting on regular daylight slide film. The painting above was photographed under tungsten lighting with tungsten-balanced slide film.

Pastorale
Roger Saddington
Acrylic on board
24" × 48" (61cm × 122cm)

Flash lighting

The light from an electronic flash also is correctly balanced for use with normal daylight film. The light appears neutral in color when exposed on film, and that's the best light to have when trying to capture the true colors of your artwork because neutral light doesn't mix with any of the colors.

Tungsten light emits a yellowish orange light, and fluorescent light appears green when photographed with normal film.

Although flash lighting emits the right color of light for accurate photography, it only appears for a moment, so you have no way to determine whether the light is striking the artwork evenly and whether unwanted reflections are present. Tungsten light is a better option because you can evaluate how the light is shining on your artwork.

Poor lighting
Unless you're using the right light correctly, your shots just won't turn out accurately. These photographs were spoiled by uncontrolled lighting: ambient lighting (above left), uneven flash lighting (above) and flare (left).

DEFINITION

ambient lighting—extra light, such as the daylight streaming in from a window

flash—a light source that emits a neutral color, though it doesn't shine long enough for the photographer to determine if it's shining evenly and in the right direction

flare—the result in a photograph when light from the light source reflects off the subject into the camera lens

Buying lights

Halogen flood lamps or work lamps, which can be found at your local hardware or discount store, are designed for general household use on patios, pools, gardens and the like. But they provide just the right light for use with tungsten-balanced film and are much less expensive than professional photography lamps.

Artists who need to photograph only small works up to two feet (about half a meter) wide should purchase two 150-watt lamps. For works up to five feet (about one and a half meters) wide, buy two 500-watt lamps. Use four 500-watt lamps for larger works.

You can buy halogen lamps that come with stands or you can make your own custom light stands. Either way, make sure the stand allows a good range of angles and heights at which to set the lamps.

Halogen lamps are quite reliable but require careful handling. Use a Phillips screwdriver to undo the housing and insert the bulb. Don't touch the glass or the globe with your bare fingers. These lights become quite hot, and that heat combined with the natural oils in your fingers can cause the glass to crack.

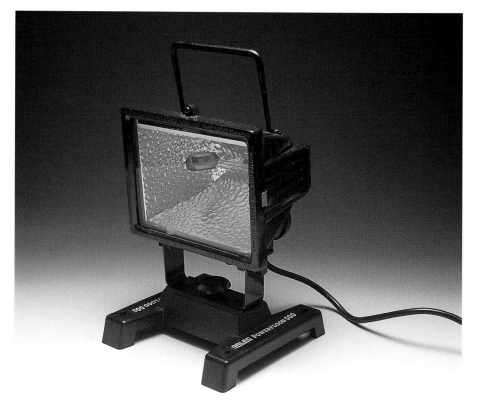

Halogen work lamp
Don't buy expensive photography gear. Simple halogen work lamps from your local store will get the job done just as well.

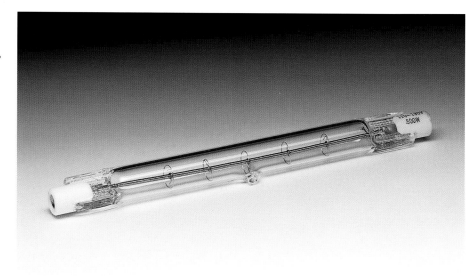

Halogen bulbs
Check prices for replacement bulbs at your local supermarket. Generic halogen bulbs often cost a fraction of the price and do the same job as brand-name bulbs from the hardware store.

Buying film

If you're shooting slides, you'll need tungsten-balanced film, identified by the letter T after the name, such as Ektachrome 64T. This film compensates for the yellow-orange cast from your halogen lamps. Look for this film in professional photography stores, suppliers and labs. I recommend starting with a film speed of 64.

If you're making prints, buy the same negative film you'd use for everyday snapshots. Even if your artwork is black and white, use color film to photograph it. Color film retains the subtle effects in black-and-white art, such as the slight color difference between an ink wash and charcoal line work, better than black-and-white film can.

Shoot black-and-white art with color film
Most black-and-white artwork will look better in books and magazines if you use color film. Though both are reproduced in black-and-white form, the photograph at top was taken with color film, and the photograph above was taken with black-and-white film.

Processing film

Most minilabs will develop your film properly, but the only way to guarantee ideal results is to go to a professional lab. Even in pro labs, though, things can go wrong. As an insurance measure, try not to develop more than two or three rolls of film at once.

Processing slides

When you take slide film to be developed, the staff will ask what services you require. The lab can develop and mount your slides for you, or for more professional-looking results, you can mount your own slides and cover the background with a custom-made mask as described on pages 32 and 33. If you want to mask and mount your own slides, ask for the "develop only" option without machine mounting.

Professional labs also can make duplicate slides from your originals. These are just slightly inferior in quality, but they're useful for press kits for which you need many copies of the same image. Unless you need fifty or more copies, though, it may be cheaper to shoot multiple originals.

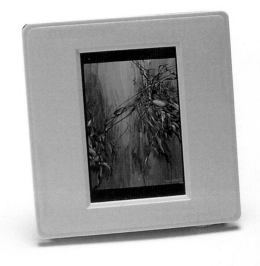

Developing options

If you want to keep the background in your shot, have the slides machine-mounted (above). If you want to make your own custom masking for a more professional look, ask the lab just to develop the film (left).

Processing negatives

If you want to make large prints, you probably don't want to print an entire roll of film in an enlarged format. Instead, have auto proofs, contact sheets or regular 4" × 6" (10cm × 15cm) prints made to preview the photos. From these, you can decide which pictures to develop at full size.

Don't be alarmed by images that appear too light or dark on contact sheets. The machine selects an average exposure for the entire sheet, and images that are lighter or darker than this average may appear inaccurate when printed at the average exposure on contact sheets. If you exposed the negatives correctly when shooting, though, the pictures will look fine when printed individually.

Make sure your negatives are correctly exposed (see page 28) before having enlarged prints made so you don't waste your money developing a bad negative. Pro labs and some mini-labs have light boxes available so you can inspect your negatives.

Contact sheets
Also known as auto proofs, these sheets help you choose which frames you want to print or enlarge so you don't have to develop them all.

Evaluating negatives

Once your film is processed, compare your negatives to your photographic print. Using a light box and a loupe, a kind of magnifying glass for viewing slides or film, check the highlight and the shadow areas for detail. Remember that on negatives, highlights will appear dark and shadows light. Focus on any areas that are either absolutely clear or dark and featureless. Does the detail match your original artwork? If not, you've made an error exposing the film and probably won't get a good print.

Correct negative
Compare the detail in the correctly exposed negative (far left) to the resulting image (left).

Watershed
Roger Saddington
Oil on canvas
36" × 48" (91cm × 122cm)

Overexposed negative
If your negative is incorrectly exposed, the printer can do little to get good results because you've lost crucial detail. This negative is overexposed, so the highlight detail is lost.

Underexposed negative
Again, the printer can do little to correct this underexposed negative. The shadow detail is lost.

Viewing slides

Magazine, book and poster publishers use special lights calibrated to 5000° K (Kelvin), the internationally recognized color of daylight, to assess the quality of slides, scans and finished print jobs. Using this light helps publishers maintain consistent color balance throughout the printing process. Staff members at a commercial gallery, though, may hold slides up to a window, view them on a poorer-quality light box or project them. Each viewing method makes photographs appear different. Think about who will be looking at your photos and how to present them when you assess the quality of your shots.

DEFINITION

light box—any device that projects light through a translucent surface so you can view film

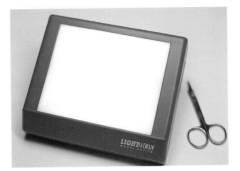

Light box

Obviously, you don't need specialized equipment to view prints, but you'll need a light box or light table to view slides. Light boxes have light sources mounted beneath translucent sheets of material. The sheet diffuses the light to create a white glow perfect for viewing slides. Most light boxes are about the size of a magazine, but you also can use smaller ones if you're dealing with slides. Don't buy the most expensive light box you can find. Light boxes are based on a simple concept, and you don't need anything high class to get the job done.

Homemade light box

If you prefer, you can make your own light box using white acrylic sheeting. Have a sheet cut to the size you'd like. Prop both ends on stacks of books or other stable props, leaving a space in the middle to place a fluorescent desk lamp or other light fixture. You also can mount the sheet on top of a simple wooden box with a small fluorescent tube inside. Tungsten lightbulbs emit too much heat to be mounted inside a box and don't provide the same even lighting as fluorescent tubes.

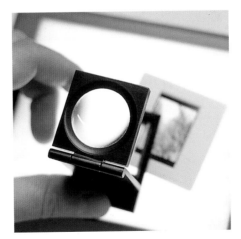

Loupe

A loupe is a small lens the viewer uses to get a closer look at slides, basically a magnifying glass. Simply place the loupe directly on top of the slide and place your eye against the loupe. Loupes vary in price from less than the cost of a roll of film to more than the cost of a new camera. Test a loupe carefully before purchase to make sure it exhibits a sharp image. For a money-saving alternative, you can use the detachable lens from any SLR camera, but you may not be able to see the entire frame at once.

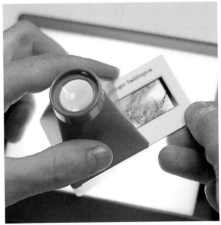

Inexpensive substitute

This loupe provides excellent sharpness at an extremely low price. Insert the slide or film into the housing where a built-in, translucent screen allows you to view slides in front of any light source, such as a window.

Presenting and storing slides

Educational institutions, funding bodies and art competitions often require artists to supply 35mm slides with their applications so they can project slides quickly and easily for large groups to see. These groups might take a dim view of slides that jam the projector and cause delays. Make sure you snapped your slide mounts together carefully, and don't put adhesive labels on your slides. Instead, write directly on the slide mounts.

You can purchase inexpensive plastic slide storage boxes from your local photo store. You also can buy transparent plastic sheets, or slide files, to store in a ring binder or filing cabinet. These allow you to view entire sheets of slides at once. Use scissors to cut the files down for storage or to present smaller numbers of slides.

Nonarchival files have frosted backs that diffuse objects behind the sheets so you have a better view of the slides. Nonarchival files are made from a rather stiff, thick plastic that has a tendency to stick to the surface of slides over time. It also emits small amounts of gas as the plastic deteriorates, which could damage slides in the very long term.

Slightly more expensive archival slide files use thinner, more flexible plastic. The sheets have transparent backs, which make viewing slides a bit more difficult.

Can your slides survive?

Several factors affect the long-term survival of your photographic materials. Most importantly, color photographic materials are not permanent. They contain soluble dyes that can deteriorate much faster than many works of art. This deterioration is, to a large extent, caused by the vibration of dye molecules at room temperature. Keep your shots in a cool, dark place to make them last longer.

Technology for color photography has developed so rapidly that no one knows how long film, negatives, slides, prints and computer printouts actually last. All we do know is that they are impermanent.

Properly made black-and-white negatives and prints can last a long time because they are made of different materials than color prints, slides and negatives.

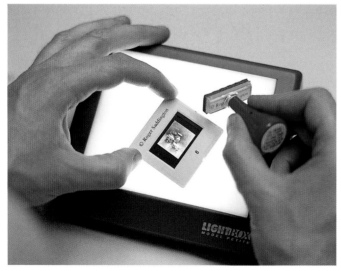

Labeling slides
Have a rubber stamp made to apply standard information, such as copyright details or a return address, on each of your slides. Otherwise, use permanent ink to write directly on the slide mount.

Slide files
You can store between sixteen and twenty-four slides in a slide file. These sheets come in either archival or nonarchival plastic.

Masking slides

If you decided not to include a background for your shots during the shoot, you can create a clean, dramatic mask around your artwork now that the slides are developed. The result, an added touch of class, is worth the effort.

Using a black background during the photo shoot doesn't produce results quite as nice as a properly made mask. The emulsion on the film can't block out light totally to give the rich, deep black of a mask, so you may still prefer to mask your slides even if you did create a background during the shoot.

You'll need Letraline tape, which is manufactured by Letraset and available at graphic art supply stores. Its smooth, matte, black finish makes the slides, regardless of the image on them, look professional.

You can use ³⁄₁₆"-inch (4.77mm) wide tape to mask out the narrow space between the artwork and the edge of the frame. You may have to use two pieces of tape in some places. The regular, nonflexible kind works best to create straight lines.

You'll also need slide mounts. Look for those with dots of tacky glue inside. This glue allows you to position the film wherever you prefer in the mount and holds the film in place as you apply the mask.

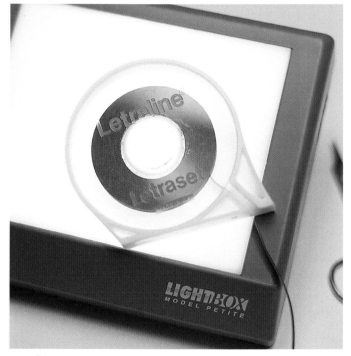

Letraline tape
This special plastic tape has absolutely clean, straight edges and is opaque. Other kinds of graphic art tape, such as metallic tape, will work as well and may be cheaper but may not look as professional.

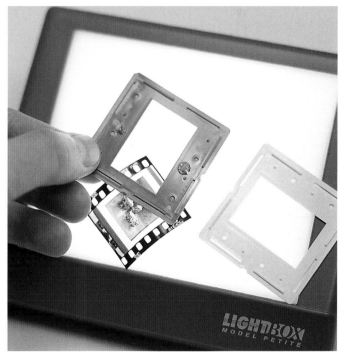

Slide mounts
These dots of glue allow you to attach and reposition the film easily.

Creating your own mask

Creating your own mask adds a slight touch of class that can make all the difference.

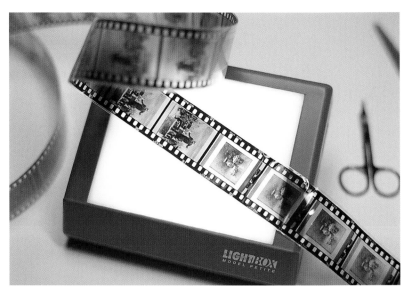

1. Process the film

Process your slides "develop only." The lab will give you a long, uncut strip of film frames.

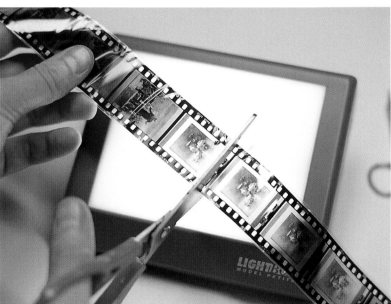

2. Cut the film

Cut the film into individual frames by following the black line between each frame with sharp scissors. The lab probably will have presented the film in a plastic sleeve, so don't worry about damaging the film with fingerprints. Cut through the sleeve and film at the same time.

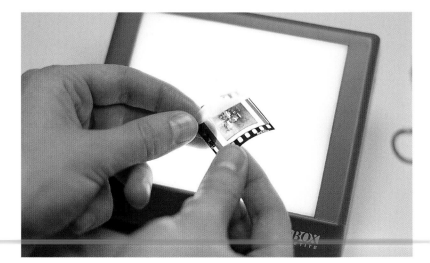

3. Remove the plastic sleeve

Remove the plastic sleeve from each frame. Don't touch the image after removing the sleeve. Handle the film by its edges instead.

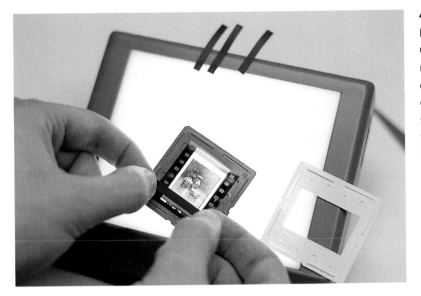

4. Position and mask the slide

Place the film segment in the slide mount. Cut four strips of tape, estimating the length needed for each edge. Place these strips directly onto the surface of the film, just covering the edges of the artwork to create a smooth, sharp edge. If the tape is too long, trim it with a pair of scissors. If you find regular scissors awkward, try a pair of nail scissors.

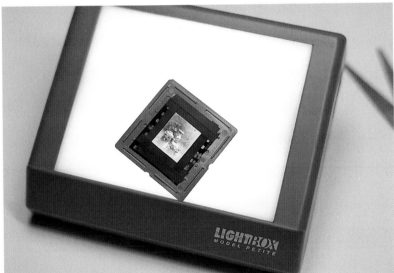

5. Finish masking the film

Continue until all of the edges of the artwork are neatly covered. If the image of your artwork isn't totally square, you'll either have to mask it as is, placing the tape along the lines of artwork, or mask over a small section of the artwork to make it appear square. Artwork that is square in reality also should appear square on the slide. If not, your camera wasn't lined up correctly. Make sure you realign it for your next photo shoot.

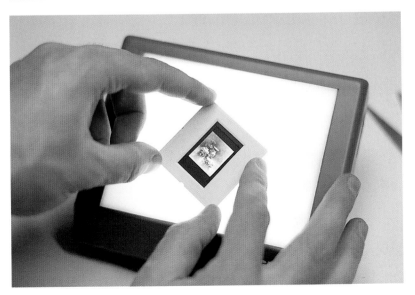

6. Snap the mount together

Snap the slide mount together to seal the film and mask inside.

Making prints

Having prints made can be a frustrating experience. The quality of your photographs rests solely in the hands of someone else. To give the technician the best possible product to start from, though, follow the following guidelines.

When shooting prints, use negative film. Negatives are the most reliable system for making prints. Don't make prints from slide film. These prints generally are harsher in contrast, which can require expensive manipulation by the lab to correct. If you want to make both prints and slides of the same subject, shoot both negative film and slide film in one photography session,

Once you've had your film developed into prints, evaluate the prints to make sure you got the quality you need from the lab. How your shots come back from a minilab is largely a matter of chance. Minilabs use an automatic exposure system when making prints. The machine takes an average light reading from your negative and exposes the print accordingly. If the average value happens to give a good result, you'll be happy, but photography doesn't always work on averages. Extremely dark or extremely light passages in your artwork may be enough to throw off the machine.

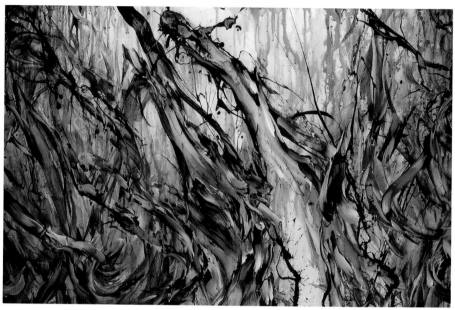

Print from a slide
Don't make prints from slides. The resulting contrast is too high.

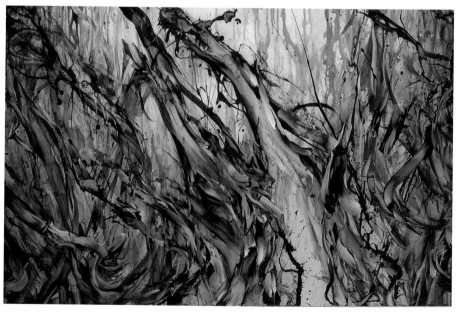

Print from a negative
If you need to make prints, shoot a roll of regular negative film instead.

Fall
Roger Saddington
Acrylic on board
31½" × 47" (80cm × 120cm)

Evaluating color prints

Look at your prints carefully. If they didn't turn out well, look for a common fault that runs through them all. Maybe they're all too light or too dark, or maybe they all have a green tinge or appear flat and washed out. Maybe just a few artworks are wrong. Determine the common factor.

If you exposed your negatives correctly, the printer should be able to correct the problem easily during the printing process. Talk to your printer, point out your observations and discuss possible solutions, such as making shots that are too dark lighter or removing some yellow from shots that have a yellow tinge.

Photography, like art, works on a system of mixing colors. If your prints have a cast, try to identify which color, such as yellow, green or blue, is too strong. The easiest place to find these tinges is in areas of light color and in white highlights.

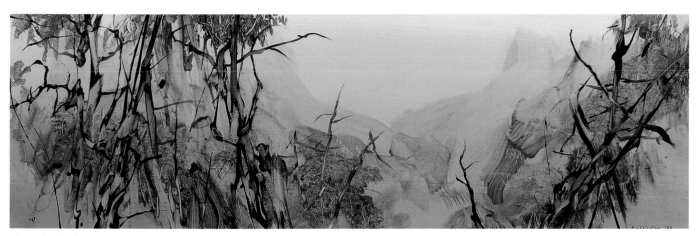

Identify faults
Compare this correct print to the inaccurate ones below.

Emergence
Roger Saddington
Acrylic on board
6" × 18" (15cm × 46cm)

 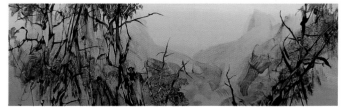

Is the tone correct?
The print at left is too light. The print at right is too dark.

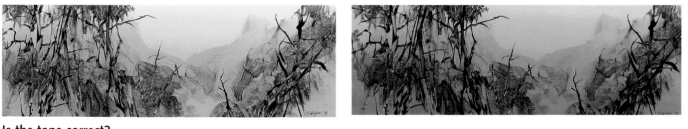

Is the color correct?
The print at left is too blue. The print at right is too red.

Evaluating black-and-white prints

If you're unhappy with the contrast in your black-and-white prints, ask the printer to reprint them at a different contrast. Try to identify exactly what you think is wrong by looking at the tones, and discuss possible solutions with your printer.

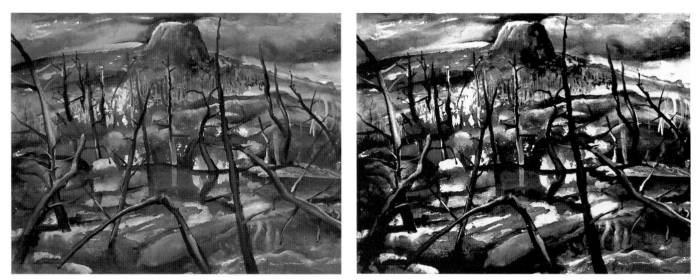

Adjust the contrast
You can enliven a dull, flat, lifeless print like the one at left by increasing the contrast. Overbearing blacks and excessively white highlights like those in the print on the right need less contrast.

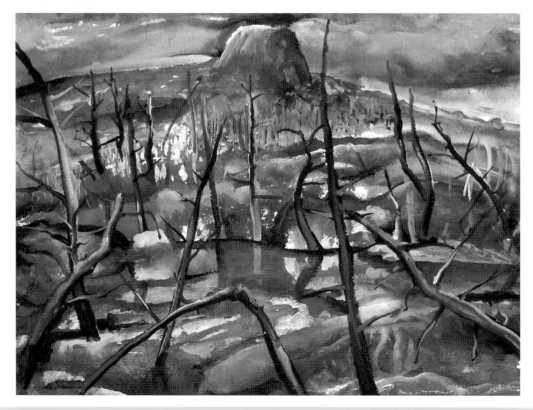

Correct print
A correctly exposed print has more contrast than the print above left without the loss of detail in the print above right.

Outlook
Roger Saddington
Gouache
8" × 12" (20cm × 30cm)

Getting the best results in your prints

Other faults may not be fixed so easily. Some minilabs increase the temperature of their developing chemicals above the normal level to speed up processing. The result, unnoticeable on the typical snapshot, is a grainy print with more contrast. Despite the best attempts by your minilab to correct faults in your prints, it may be impossible to print with a full range of tones under these conditions. Shadows will tend to fill in toward solid black, and highlights will lose detail, becoming more white than necessary. If this becomes a problem, take your film to a professional lab. Pro labs are much more likely to process at the correct temperature and replace chemicals at recommended intervals because professional photographers constantly scrutinize their work.

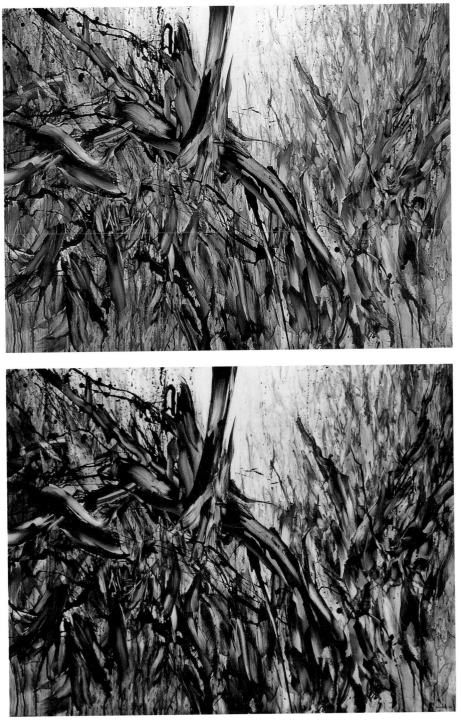

Head to the pro lab

Minilabs are designed to develop the average snapshot, not to achieve professional results. If your prints from a minilab have too much contrast, take them to a professional lab for reprinting. The print at top is from a professional lab. The print above is from a minilab.

Crash
Roger Saddington
Acrylic on board
36" × 48" (91cm × 122cm)

Making enlarged prints

When you have prints made, what you're really paying for isn't as much the materials you use, but the printer's time and labor. So the cost of an enlargement depends on the time the printer spends getting the enlargement to match the result you want.

Most pro labs offer a few levels of service. You can have the enlargements exposed automatically as at a minilab. You can have the printer tinker with the image a bit to ensure adequate results. Or you can have the printer spend as much time as he or she needs to achieve top-quality results. This service usually is called custom printing.

Discuss your options with the printer. Take a proof or small print with you and attach a note describing how you want the final print to differ. You may write "a little darker overall" or "more yellow, please." Be specific about what you want. If your artwork has passages that must be absolutely accurate, point them out. Get verbal confirmation from the technician that the lab can produce the particular result required. Make sure the lab writes your instructions on the order form so the printer has no confusion as to what you need and expect.

Evaluate your enlargements

As with regular prints, inspect your results carefully and try to identify any faults, such as color casts, darkness or dull highlights. Discuss these with the printer; the technician

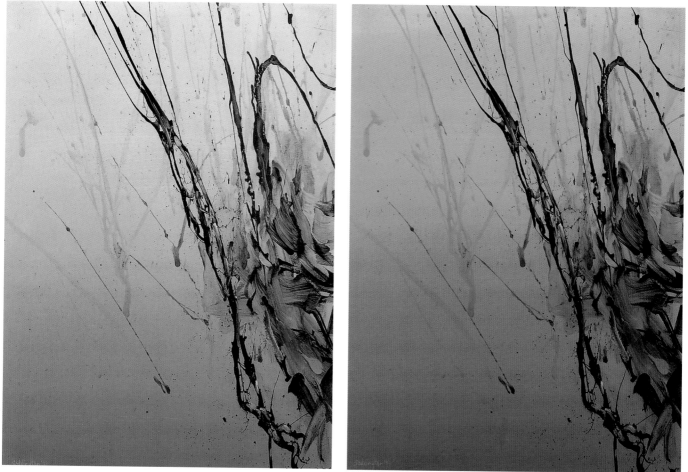

Provide examples
Tell your lab technician that, for instance, the print at left needs more magenta and the print at right has too much. With this guidance, the lab likely will come up with the print on page 39, halfway between the others.

normally can fix it. If you supplied a print you want the printer to match the enlargement to, the lab won't have much of an excuse if it returns an unsatisfactory print.

If you need an enlargement that should differ a bit from the print you've brought to match, be patient. If you need less yellow, for example, the printer may go too far or not far enough. Be understanding of this process. Any additional material you can supply to assist the printer, such as other prints or even small original artwork, will increase your chances of a satisfactory result.

Be cost-effective

Determine the most cost-effective process to get the print you want. Paying for two automatic enlargements may be more expensive than just paying for the printer to do the job manually. For larger, more expensive prints, have the printer make smaller 4" × 6" (10cm × 15cm) prints that meet your standards first. Once you have a good print at this size, the printer should be able to match the quality on an enlargement easily.

Try to develop a relationship with your lab and, if possible, a particular technician. Over time, this person will come to know what you expect in terms of quality.

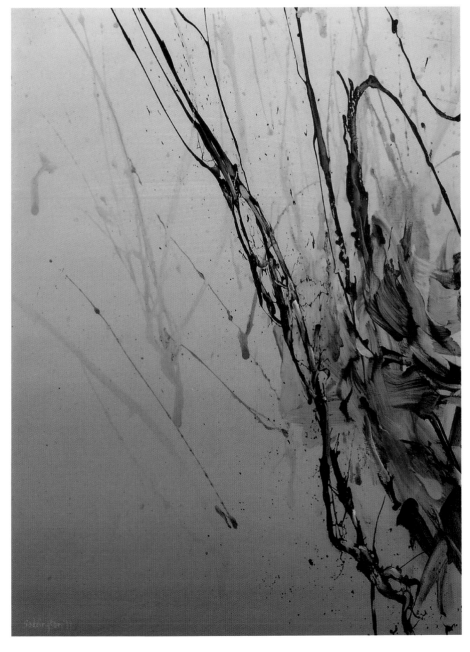

Examples get results

With the information I gave the printer about the prints on page 38, the printer produced this compromise, a close match to the original art.

Tracery
Roger Saddington
Acrylic on board
12" × 8" (30cm × 20cm)

Using digital photography

Computer printouts are a convenient and economical option for those who already own a computer and quality printer. Unfortunately, many digital printers cope poorly with the unique demands of artwork photography. Most affordable digital cameras have low resolutions and thus don't deliver the professional results artists need.

Digital resolution

You need a camera with good resolution to get quality results. All digital images are made up of tiny squares of color called pixels. The continuous tones and colors of real life are converted into a blanket of these pixels. When pixels are small enough, they visually blend together giving a seamless impression of the finished image. If the pixels aren't small enough, the image appears ragged or pixilated.

The resolution of a particular image is the number of pixels in that image, usually indicated in pixels per inch (ppi) or dots per inch (dpi). For an image to be successfully enlarged to the size of a normal photographic print, 4" × 6" (10cm × 15cm), without appearing ragged, you need a camera capable of recording well over a million pixels at the moment of exposure. That's quite a lot of information to capture in a split second, so cameras capable of it can be quite pricey.

Artists who intend to produce smaller images may find a digital camera useful. But if you want images larger than a standard photographic print, forget digital cameras for the time being. Technology continues to improve, but resolution still poses a

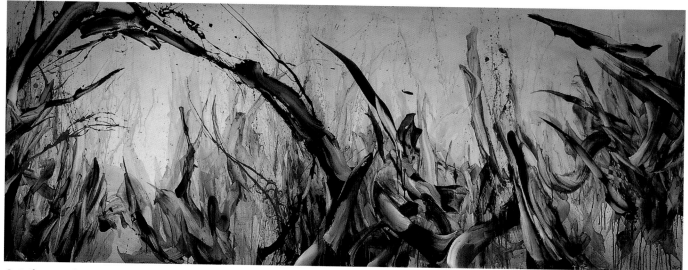

Get the resolution right
Images with too few pixels may appear ragged. Compare this image, which has enough pixels for high-quality printing, to the image on page 41.

Aftermath
Roger Saddington
Acrylic on board
36" × 96" (91cm × 244cm)

problem for larger prints. The printer and/or computer monitor can be more to blame than the camera for less-than-ideal results.

If you really want to purchase a digital camera, the most important thing to know before buying is the image size the camera can produce at 300dpi, the point at which pixels become small enough to produce a high-quality picture.

To calculate image size at 300dpi, divide the resolution by 300. For a camera claiming a resolution 1200 × 1600 pixels, perform the following calculations:

$$1200 \div 300 = 4$$
$$1600 \div 300 = 5\tfrac{1}{3}$$

This camera can produce a 4" × 5⅓" (10cm × 13cm) print at 300dpi. If this size works for you, you've found a camera. Obviously, you can produce images of whatever size you want with this camera, but those larger than 4" × 5⅓" (10cm × 13 cm) may appear ragged. Cameras that offer a higher resolution will produce larger images at 300dpi. Resolution is the key; other features of digital cameras are secondary in terms of artwork photography.

Make sure the resolution the salesperson quotes is the actual or optical resolution. Some manufacturers use trick terms like "virtual" resolution and "with interpolation" to make their equipment seem more sophisticated. Be wary of a particular model that seems to offer a very high resolution at a relatively low price.

Ragged resolution
This image has too few pixels.

Producing a quality digital image

Less-than-perfect results are more obvious in artwork photography than in regular photography because the artwork photographer has the extra burden of matching the photograph to the original artwork. Regular photography can be declared successful if the result looks good, regardless of how it compares to the original scene. Matching a digital image to the original artwork is more difficult than getting a matching result on film.

Software and printers

Once an image is in digital form, you have to alter it using computer software to correct for the idiosyncrasies of your printer. Although most programs are excellent, calibrating your computer, monitor and printer to pro-duce accurate images can be a time-consuming and frustrating process.

Even the best printers cannot repro-duce certain colors, and some colors are impossible to obtain without sacri-ficing others. Each printer is different, so if you want to make a copy of the resulting print on another printer, you'll be back at square one. The biggest problems are the inconsisten-cies of the computer and printer; you never know when either one will have difficulty rendering a particular color accurately.

You can minimize differences between the artwork and the digital image by carefully adjusting the image in a high-quality program, such as Adobe Photoshop.

Subtle colors can translate into obvious discrepancies when printing a digital image. Digital images of deli-cate watercolor washes, light draw-ings, and paintings with light hues yield varying results as the printer searches its relatively basic resources for a suitable match. Very light colors and off-whites may appear darker and dirtier or may burn out altogether, leaving only the white paper. Even artwork with white areas can have unexpected color casts as the printer tries to interpret tiny variations of color that are more subtle than its printing capabilities. Saturated colors generally reproduce well, but they probably will lack subtlety compared to your original artwork.

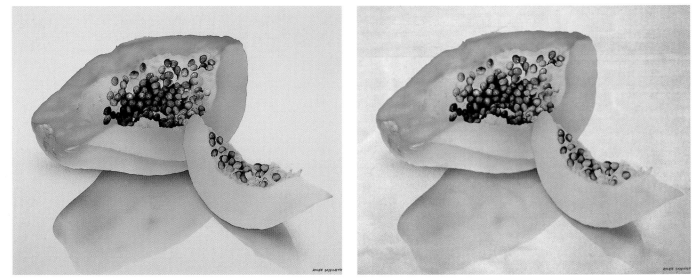

Digital prints may not work for your art
Certain types of artwork, such as watercolors, drawings and other delicate techniques, may lack subtlety when printed on digital printers. They also may shift in color. Compare the painting at left to the digital print at right.

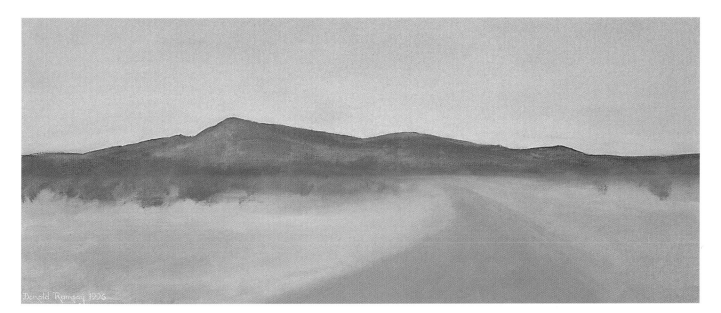

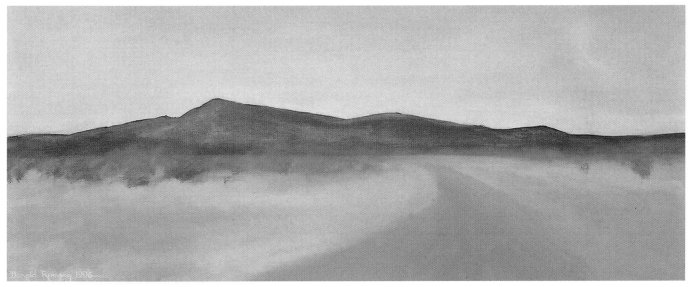

Conventional photography works best

The image above is a photographic print of the painting at top. Notice how closely the print matches the painting. The photographic print matches the painting much more accurately than the digital image on page 42.

Evening, East Kimberly
Donald Ramsay
Oil on canvas
10" x 24" (25cm x 61cm)

Setting Up Your Studio

Consider the various places you can set up to take photos. You'll need an area without any ambient lighting, such as fluorescent lights, desk lamps, candles or daylight. If you can't eliminate these lights completely, take photographs at night (moonlight can still cause problems) or make sure ambient light forms the smallest possible percentage of the light falling on your subject. Otherwise, color casts will creep into your photos. Shut off all extra lights. The only light in the room should be coming from your halogen lamp.

Dust also can make photography difficult. A dirty work space can make cleaning lenses and loading film a chore, not to mention the harm dust can cause artwork. Art studios are particularly prone to these problems. Charcoal dust, partially dried paint, water and solvents are all dangerous for your camera gear and artwork. Clean the area you've chosen and allow time for residual dust to settle before you begin your photography session.

Setting up two-dimensional artwork

Consider how much room you'll need. The ideal place would be one where you can leave your equipment set up. If you can clear enough room, you could use your art studio. If not, a living room, garage or other large area will work just as well. Beware of the conditions of the room, such as moisture in a garage, before exposing works on paper or other fragile work to those conditions. Clear one wall entirely of all objects and furniture. The less clutter the better. Light can spoil your results by bouncing off furniture and other objects if they are too close to the subject. Beware of colored walls and floors, which will reflect color onto the artwork. To avoid these reflections, simply hang a cheap black cotton cloth behind the artwork or set the cloth on the floor below it.

1. Find a roomy area

Choose an area wide enough that you can position lights a sufficient distance from the artwork. For small works up to three feet (about one meter) wide, allow at least three feet (one meter) on either side. For larger works up to six feet (almost two meters) wide, allow at least six feet (two meters) on either side. Extremely large works require even more space. Be realistic about what you can achieve in the area available to you.

2. Maximize your space

Make the most of the space available by placing large rectangular artwork on its shortest side.

Setting up two-dimensional artwork

3. Raise the artwork off the floor

Devise a way of lifting artwork off the floor.
This need not be a high-tech exercise. I set
paintings on acrylic paint tubs and lean the
top of the artwork against a wall. Milk crates
also work well. Lean the artwork at as little an
angle as possible while keeping the arrange-
ment sturdy. Use something that is stable and
stacks well but doesn't stick out too far from
the artwork. Use matte black objects to mini-
mize reflections. Drape black cloth over light-
colored objects or the floor. You can mount
artwork on an easel, but some of the painting
may be obscured by the slats holding it in
place or by their shadows. Also remove the
glass if the painting has been framed behind
glass. It will cause unwanted reflections.

4. Set up light stands

Create or buy light stands that allow you to
adjust the height of the lamps roughly to the
center of the artwork. Again, this need not be
high tech. Milk crates, chairs, stools, steplad-
ders or shelving units work well. You also can
construct a simple stand using cheap lumber
and particleboard (see step 5).

5. Or construct a light stand

Attach a tall piece of lumber to a particle-
board base with brackets. Attach the lights
with heavy-duty tape, or place large hooks or
other clip devices at varying heights along the
timber. Make sure the stands are sturdy. You
may need to stabilize the stand by placing
heavy objects, such as books, on top of the
base. Remember that halogen lamps get quite
hot, so avoid flammable materials, allow ade-
quate ventilation space and don't leave them
on when you're away from the area.

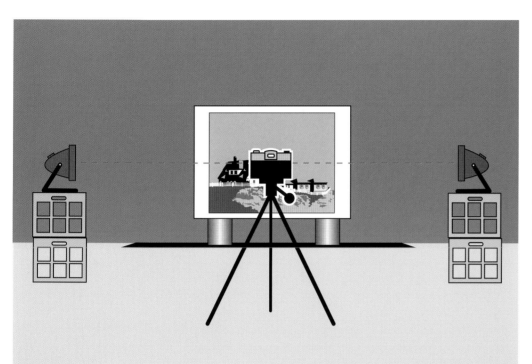

6. Center the camera

Prop the largest artwork you intend to photograph against the wall. If you set up the area around your largest artwork, you won't have to move the lamps to accommodate smaller pieces. If you set up around a small artwork, though, you'll have to rearrange your lamps for larger artwork to make sure the light covers the entire painting. Mount the camera on a tripod or support and adjust the tripod until the camera lens is vertically and horizontally centered on the artwork.

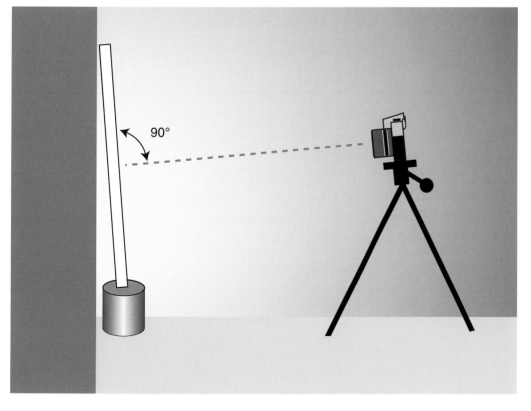

7. Tilt the camera

Most artwork will lean back slightly when you prop it against a wall. To compensate for this angle, position the camera slightly higher than the artwork's center and point the lens downward so the line of sight, or axis, of the lens barrel is perpendicular to the surface of the artwork. The front plane of the lens should be parallel to the surface of the artwork.

Setting up two-dimensional artwork

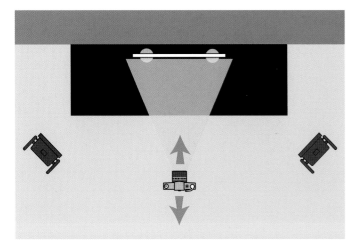

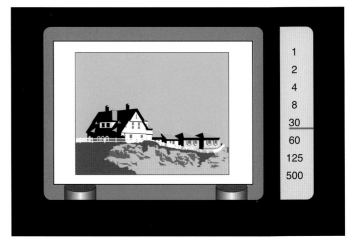

8. Establish the position of the tripod

Looking through the viewfinder, move the tripod backward or forward until the artwork fills the frame as much as possible. Be careful not to cut off any of the image, though. You may have to reposition the camera to take a vertical shot to get the best fit. Adjust the tripod so the artwork's edges are parallel to the edges of the viewfinder frame, allowing a small gap between each side of the artwork and each edge of the viewfinder. Most viewfinders don't exactly indicate the position of the edge of the film, so you have to allow a little extra space to avoid chopping off part of the artwork. Slide mounts and automatic print machines also might cut off a small part of the frame.

Few artworks fill the exact shape of the viewfinder. You can create a background now or mask out the gaps when your film comes back from the lab (see pages 32 and 33) to make your shots look more professional. If you want to make a background now, use large sheets or rolls of colored paper or thin sheets of painted particleboard.

9. Set up the lamps

Imagine you're looking at your workstation from an aerial view. Place one light on either side of the artwork. Draw an imaginary line on the floor from each side of the artwork at a 45-degree angle to the wall, and position the lamp somewhere along the line. Your best estimate of the angle will be fine.

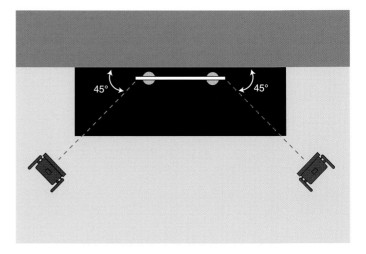

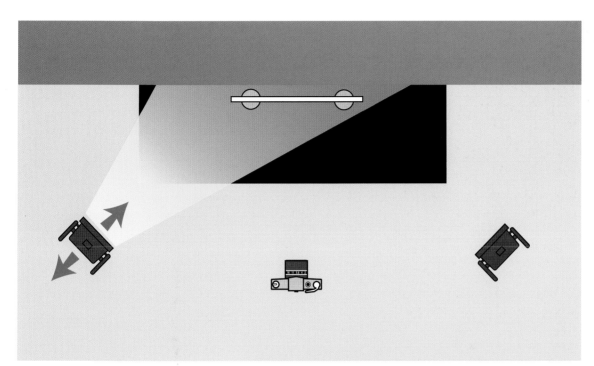

10. Adjust the lamps

Turn on one lamp. Move it back and forth along the imaginary 45-degree line, keeping the lamp aimed at the edge of the opposite side of the artwork. Notice that the farther away the light is, the larger the size and range of the beam. Move the lamp back until its beam covers the entire surface of the artwork. Allow a good amount of the lamp's beam to fall outside the dimensions of the artwork. Turn this lamp off and repeat the process with each of the other lamps. Each lamp should be an equal distance from the artwork to maintain even lighting. If you can't make the light from each lamp cover the entire artwork because of lack of space, set up in a larger area or forgo photographing objects this large. If you have just a few large pieces, take them to a professional photographer.

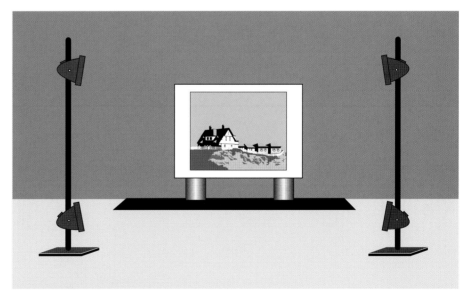

11. Use the correct number of lamps

For artwork over five feet (about one and a half meters) wide, use four lamps instead of two. All four lamps should be the same distance from the artwork. Place the top two lamps slightly higher than the top of the artwork and the bottom two slightly lower than the bottom of the artwork. Shine each light toward the opposite edge of the artwork, making sure that each of the four beams of light covers the entire surface of the artwork. This ensures that the artwork is lit evenly and that ridges of paint in textured passages, such as those in impasto painting, are lit from both top and bottom.

Setting up two-dimensional artwork

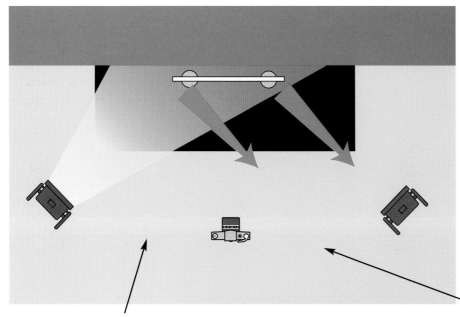

12. Look for unwanted reflections

Determine whether unwanted reflections are present. With just the lamp you're checking turned on, follow the light beam from the lamp to the closest edge of the artwork. The light beam will bounce away from the art at a 45-degree angle toward the opposite side of the workstation. Use your hand to trace the path of light if necessary. The beam should bounce off small- to medium-size artwork to a point between the camera and the other lamp. Make sure the light reflects past the camera and not into the lens. Check each lamp this way.

Light from the lamp on the left should reflect toward this side of the camera.

If light from the lamp on the left reflects here, the reflection will spoil your photos

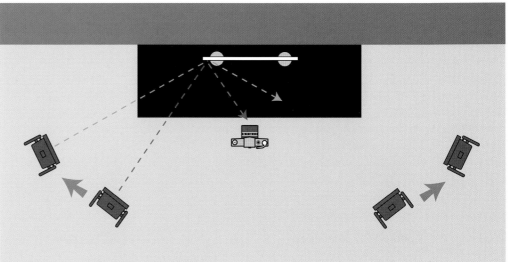

13. Adjust the lamps for large artwork

The beam may reflect from a larger artwork back to the camera or between the camera and the lamp it originated from. These reflections will appear in the photograph. Turn the lamps on and place your head near the camera. If you see a spot of flare on the artwork, the light is reflecting toward the camera. Although artwork with a matte finish won't reflect as much light, the flare still will cause the color to become washed out.

To get rid of flare, move the lamps outward to a more acute angle with the wall. For example, move the lamps so the imaginary line from the edge of the artwork forms a 30-degree angle with the wall. Experiment with the imaginary light beam once again. This time it should strike the artwork at 30 degrees and bounce off at the same angle. As you decrease the angle, remember to rotate the lamp so it continues to point to the opposite edge of the artwork. The reflected beam now should pass harmlessly to the opposite side of the camera. After adjusting the angle between the lamps and the wall, you may need to move the lamps backward and forward along the new angle's line to ensure that the beam still covers the entire surface of the artwork.

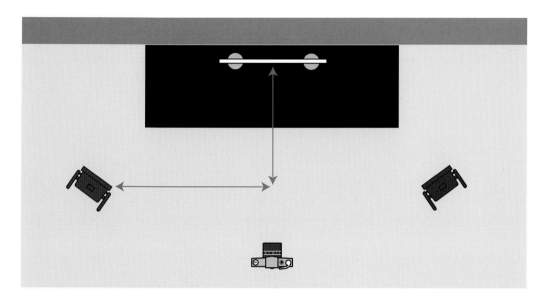

14. Write down dimensions

Now that your lights are positioned correctly for the largest work you intend to photograph, record the setup of your lights, camera and artwork. The lights as you've set them up will always shine evenly on artworks of equal and smaller sizes. If you can, mark the locations of your equipment with tape so it'll be easy to set up next time. Or, even better, just leave your equipment set up.

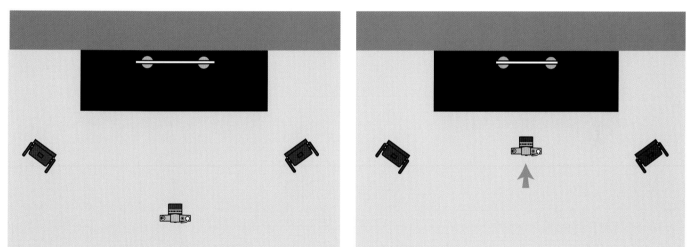

15. Move the tripod up for smaller artwork

You can substitute smaller work into the setup and move the tripod forward without altering the lighting setup. If you want to photograph larger artwork, however, you'll have to start over to make sure unwanted reflections don't appear.

Setting up three-dimensional artwork

Photographing two-dimensional objects is a pretty dry business and a necessary evil for most artists. Everything has to be right, and there really isn't much room for creativity. Artists photographing three-dimensional artwork, though, get to have all the fun.

In this form of photography, you must interpret the subject rather than just copy it. Choose a suitable surface such as a table or, for really large objects, the floor. The whole process will be easier and safer for the artwork if you allow yourself a bit of room to move. Choose the most spacious area and the largest table you can find. To protect the artwork, remove it from the area once you've established its general position. Return it only after everything else is in place and you're ready to shoot.

1. Choose a background

Get a roll of thick, clean, smooth paper from a photo supply store or arts and crafts shop. It should be at least wide enough to allow about a foot (a third of a meter) on either side of the object you're photographing. Rolls of background paper are available in a wide range of colors. Professional photo stores have paper that gradates from light to dark, as shown in the background above, though the rolls are quite expensive. You can make one of these gradated backgrounds with an airbrush. Err on the conservative side, though, as elaborate backgrounds can become dated. White, neutral gray, black and gradations of these colors are your best options.

2. Set up your workstation

Use the roll to create a seamless background. Suspend the paper behind and above the subject in a gradually curved shape. Cut an appropriate length of paper from the roll, allowing more paper for larger objects or if photographing from a low angle. The easiest way to hold the paper up behind the subject is to use household items such as heavy books to hold the backdrop in place. Fold the back end of the paper over the top of the pile of books, and slip the end between two of the books to hold it in place. You may want to bind the books together to keep them from toppling over.

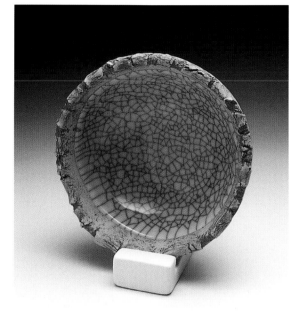

3. Make a base

You may have to make a special base or cradle to hold delicate or awkward objects. Sand and carefully spray paint the stand the same color as your background to make it discreet. You'll position the object and base later.

Crackle Bowl
Rynne Tanton

4. Suspend the lamp

Get a piece of cheap lumber thick enough to support the weight of the lamp plus some extra weight. Suspend this lumber across and well above the workstation, just in front of the artwork. You can prop the lumber on household furniture, such as a ladder on one side and a bookcase on the other, for instance. Choose whichever items are the safest and sturdiest for supporting the beam. For safety and stability, make sure the lumber is long enough to extend beyond the supports. Tape the beam down with heavy-duty tape. Attach the lamp to the beam so it's centered over the subject. Make sure the light covers the artwork and the area immediately surrounding it. Tape the lamp cord safely out of the way along the beam and down to the floor, but don't ever put tape on the lamp itself. The housing becomes very hot and could melt the tape. You can position the lamp elsewhere or include more lamps so light also shines from other directions. Experiment to find the look you like best, but start simply. One lamp may look best.

Setting up three-dimensional artwork

5. Make a frame

Create a diffuser frame to hang around the lamp. You'll hang fabric from this frame to soften the harsh light. Four lengths of light wood will work fine. Nail or screw the boards together (below left) to make a square or rectangle about the size of the area being photographed. A three-foot (one-meter) square frame usually works well. You also can look in art supply stores for a canvas stretcher bar that fits together without nails or screws (below right).

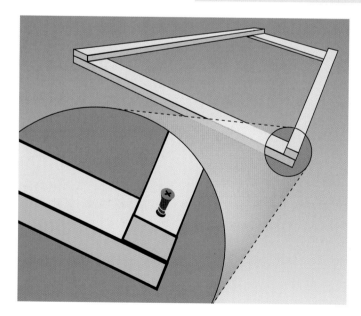

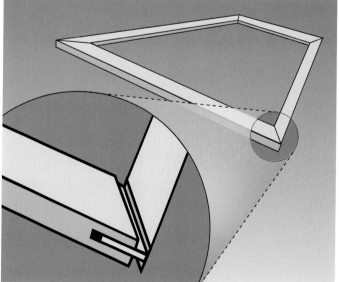

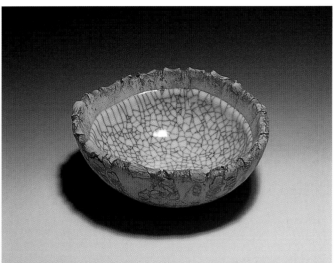

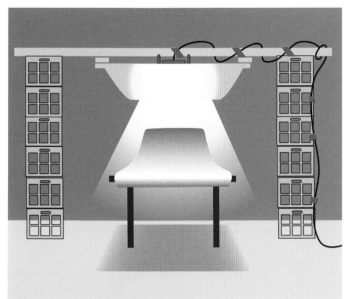

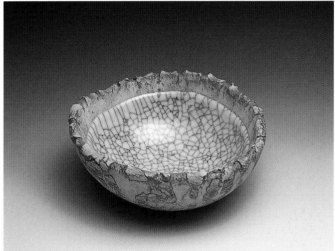

6. Attach the fabric to the frame

Find a piece of translucent white fabric that is longer than the frame so it will droop well below the lamp. Remember, these lamps can become very hot. It's also a good idea to ventilate the area with a fan if at all possible. Professional photographers' lights often have fans built in to keep the lights and surrounding items cool. Staple, tack or glue the shorter edges of the fabric to opposite sides of the frame, allowing the longer sides of the material to sag below. Firmly attach the frame to the wooden beam with heavy-duty tape, wire or nails so the frame surrounds the lamp. The fabric should drape between the lamp and the artwork below, softening the rather harsh halogen light beam.

You can use alternative frames if you prefer. For instance, you can cut a circle of fabric instead of a rectangle and attach it to a hula hoop. The idea is to let the fabric droop well below the hot light. Remember never to leave the lamp on when you leave the area.

7. Shoot with or without the diffuser

The diffuser effect created by the frame and fabric is a standard technique in professional photography. Observe the effect of a diffuser on the shiny, reflective object above. The highlight on the object above, photographed with the diffuser, is much larger and softer than it is without the diffuser (at top). The diffuser also softens shadows, giving a more even, pleasing light. If a harsher light or more contrast is appropriate, go without the diffuser. Try it both ways. A little experience will help you decide what represents your artwork the best.

Setting up three-dimensional artwork

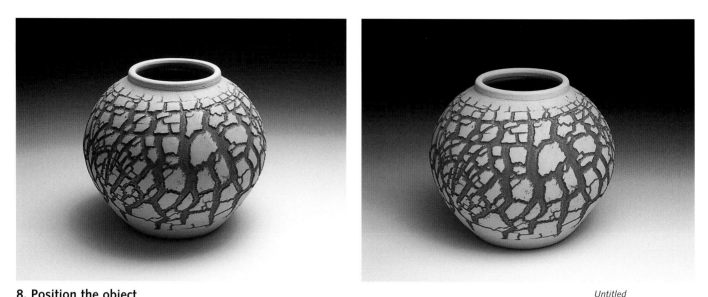

8. Position the object

To accommodate the different demands of different artwork—shapes, textures and sizes—make sure you can move the lights in relation to the artwork. If you can't move the lamp backward and forward, maybe you can move the table and artwork instead. To prevent damage, remove the artwork before changing the setup. By moving the lamp or the object, you can get the best lighting for each piece of artwork. Place a pot with a lot of texture, for instance, directly below or just slightly behind the light, as at left. The idea is to accentuate interesting textures by grazing light across the front of the subject; the light will catch the uppermost features of textured passages, throwing other spaces into shadow. Try placing the pot further back behind the lamp as at right. You'll notice that the front is more evenly lit and less texture shows.

9. Plan reflections

Position shiny, reflective objects so the diffuser sheet appears as a large, white highlight on the surface, as on this wine glass. Be aware that other objects, including the photographer, also can appear as reflections.

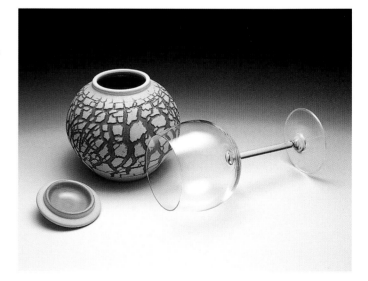

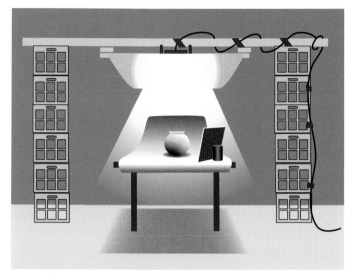

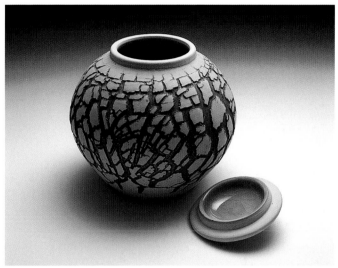

10. Make a reflector card

If you like the way light is falling on the object but find that deep shadows obscure part of the object, make a reflector card out of rigid white board. Any type of cardboard or particleboard will work. If you can't find white board, paint it white. Adjust the angle of the board, reflecting the light from above into the shadow areas. You may need to get someone to hold the board in position, or you can prop it against a chair or other item of furniture. Flexible wire and heavy-duty tape also secure reflectors in place well. Even reflector cards small enough to be propped up near your subject just outside the view of the camera can be surprisingly effective. You'll be amazed by how you can control light with a little practice.

Experiment! Position your subject well forward of the lamp and bounce light onto the front of the artwork with a reflector card placed near the camera. Make a silver reflector instead of a white one by gluing aluminum foil, shiny side up, onto a sheet of particleboard. Wrinkled foil can give a particularly flattering light. You even can warm up or cool down the scene by reflecting light from boards covered with colored paint. Be tasteful, though. The point is to display the inherent qualities of the artwork, not to create a Hollywood light show.

It makes a difference

The image above was photographed using a reflector card. The image at top was shot without one.

Taking the Picture

Most people think automatic cameras are easier to use than manual cameras. Surprisingly, the totally manual camera provides the simplest and most versatile way to photograph artwork. Both manual and automatic cameras will work for artwork photography. You'll need a gray card, available from professional photo shops and some amateur suppliers. The gray coloring, referred to as 18 percent gray, is a uniform standard for measuring light levels. The average tonal values of most scenes in photography end up somewhere near 18 percent gray, so camera manufacturers use this value to calibrate the light meter in your camera.

Using a manual camera

Your manual camera will suggest a shutter speed based on the amount of light hitting the gray card. You'll simply set the camera to that shutter speed and start taking pictures.

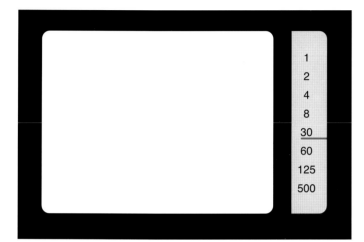

1. Find the light meter

Locate the TTL (through-the-lens) meter in your camera. In the viewfinder, you'll see a needle, lights or series of numbers next to the screen. The needle moves in response to changes in the amount of light the camera is seeing. There are variations of this design, but the correct exposure always will be highlighted in a logical way. If you're unsure how your light meter works, ask someone at your local camera store for help. For some cameras, you have to press the shutter release button halfway down to get a light reading. If your meter doesn't work, the battery may be dead. Local camera stores can supply you with a new one and help install it.

2. Set the film speed dial

Set the film speed dial to match the film in the camera.

Using a manual camera

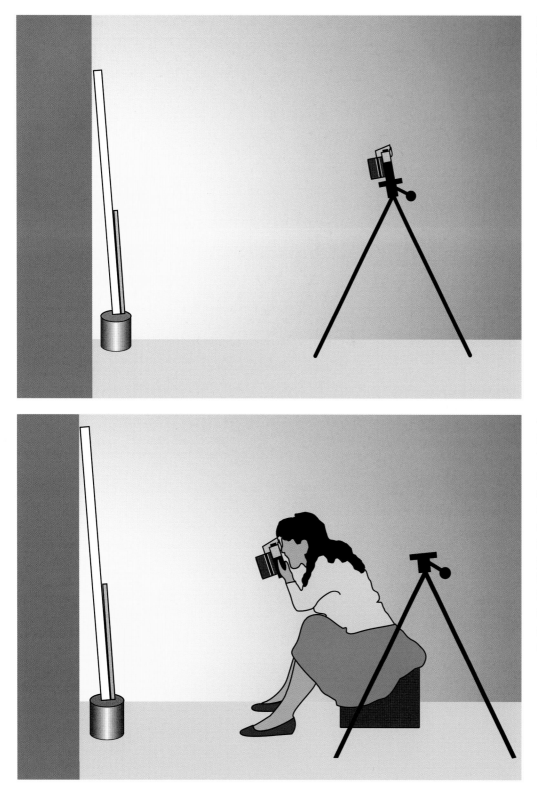

3. Position the gray card

Place a gray card against the front of the artwork, or remove fragile art and position the card in its place. Make sure the card is leaning back at the same angle the art was leaning so it receives the same amount of light.

4. Fill the viewfinder with the gray card

Turn the lamps on, turn off any other light sources and check for ambient lighting. Remove the camera from its support. Hold it close to the gray card and look through the viewfinder, adjusting your position until the card fills the entire screen. Be careful not to block any of the light falling on the gray card. Otherwise the reading you're about to take won't be accurate.

aperture ring shutter speed dial

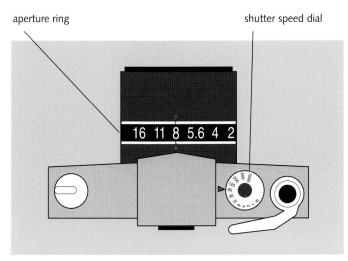

5. Take a gray card reading

Set the aperture ring to f8. Keeping the viewfinder filled with the gray card, note the camera's suggested shutter speed. On some models this will appear as an illuminated number. On others you'll have to adjust the shutter speed dial, usually located near the shutter release at the top right of the camera, until the needle on the light meter is in the center of its range. That number will be the correct reading. The meter may indicate the correct exposure at 60, for example. This stands for ⅟₆₀ second, the amount of time the film will be exposed to light. Then simply set the shutter speed dial to 60. Most shutter speed dials range from 1 to 500.

Making sure the shutter speed is set to match this suggestion, return the camera to its support. From now on, providing you don't move the lights, ⅟₆₀ second at f8 will be the correct exposure for all of your two-dimensional artwork. Next time you shoot, simply place the lamps in exactly the same spot and set the camera to ⅟₆₀ second at f8. Remember that this is only an example. Your own reading will depend on the amount of light falling on the subject, but always begin at f8 on the aperture ring. From now on, as you place different artwork in front of the camera, the TTL meter may change its suggested exposure. Ignore these changes. The reading from the gray card is the correct shutter speed.

For three-dimensional art, you may not be able to establish a standard shutter speed for each object because you may have to move your lamps for each object you photograph. A standard exposure is possible in two-dimensional artwork photography only because the lights and the artwork are in exactly the same position every time. Photographers of three-dimensional artwork must repeat this step with a gray card each time you move the lamps.

DEFINITION

aperture ring—the ring that allows you to control the size of the opening that allows light in to the film

shutter speed—the amount of time the shutter stays open to allow light to hit the film

Using a manual camera

 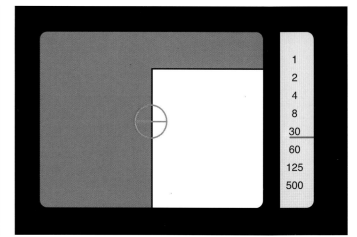

6. Focus

Focus accurately before shooting. Identify clearly defined shapes in your artwork and use them to help you focus. If there are no clear shapes in your work, place a hard-edged object such as the gray card flush against the artwork and focus using the edge. If your camera has a split-screen device, you can focus precisely by making sure lines within the circle meet. The image on the left shows the viewfinder's view of an out-of-focus image. The image at right shows a correctly focused image.

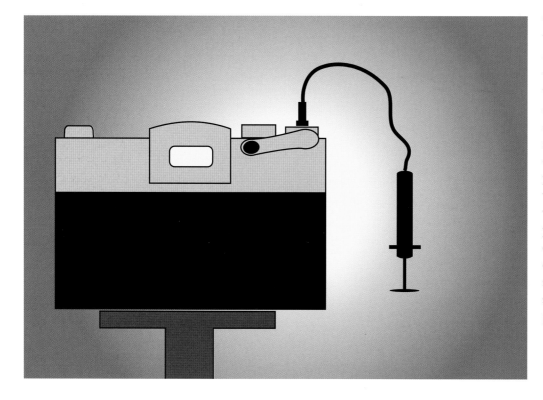

7. Reduce camera shake

To avoid camera shake during exposure, use a cable release, which allows you to take a photograph without touching the camera. These are inexpensive and available from most camera stores. Check the viewfinder every frame or two to make sure you haven't moved the camera, focus ring or tripod legs accidentally as you wound the film. If your camera doesn't accept a cable release, select the time delay function to avoid camera shake. The camera will take the shot a few seconds after you press the shutter release button.

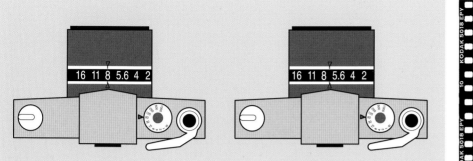

8. Bracket

To test the accuracy of your shots, it's a good idea to shoot a test roll of film by bracketing, or taking photographs of the same image at a few different exposures. Then you can choose the exposure that best matches your artwork. For example, if your work is very dark, you may find you want to slightly overexpose your shots to open up the detail in deep shadows.

Each number on the aperture ring on the lens barrel represents a "stop" of light or an increment. By adjusting this ring, you adjust the size of the aperture and how much light it lets in. Rotate the ring. The number of clicks between f-stop numbers, such as f8, will depend on the design of your camera. If one click takes you halfway between two numbers, this is a half stop. If one click takes you directly to the next number along the dial, this is one stop, but you still can move in half-stop increments by setting the ring half way between two stops. Always set the shutter speed to a whole number; you can damage the camera by setting it between increments.

For our example—an exposure of ⅟₆₀ second at f8—shoot one frame at this value, as shown above left. Then move the aperture ring a half stop toward the smaller numbers as shown above right. Shoot another photograph at this setting and then move another half stop down again. Repeat the process again, moving down to f4 and taking a shot at both half stops. You have now taken five bracketed photographs, all with slightly different amounts of light hitting the film. Now move the aperture ring back to f8—or your original f-stop—and take a photograph at each half stop up to f16. Now you've taken nine bracketed photographs since you began. Take notes on the f-stop number you used for each shot so you can compare the exposures after you process the film.

DEFINITION

bracket—to take a few photographs of the same image at different exposures to guarantee that you get one that matches your artwork

f-stop—a degree of measurement on the aperture ring

correct exposure

9. Choose an exposure

Once you process the film, you'll have a wide range of exposure values to choose from. If you want to finish the roll, take bracketed shots of a few other artworks. Inspect your finished results and choose the exposure value that best represents your artwork. Take note of this value. If you set up your workstation in the same place, you can use this as your standard exposure without bracketing. Simply set up your lights in exactly the same position, place the artwork in exactly the same spot relative to the lights, set the camera to the standard exposure you've selected from the bracketed shots, and shoot.

Off 'n Running
Helene Seymour
Oil on board
19½" × 23½" (50cm × 60cm)

Aperture and shutter priority cameras are automatic cameras, which means they'll automatically set the exposure based on the aperture setting or shutter speed you select. For aperture priority cameras, you'll select an aperture setting and let the camera determine the shutter speed based on the light hitting the gray card. For shutter priority cameras, you'll select a shutter speed and let the camera determine the aperture setting based on the light hitting a gray card. The key is to make sure the camera setting always matches the gray card reading. The setting may change when the camera is looking at your artwork instead of the gray card. Just return the setting to the gray card reading before you take the picture.

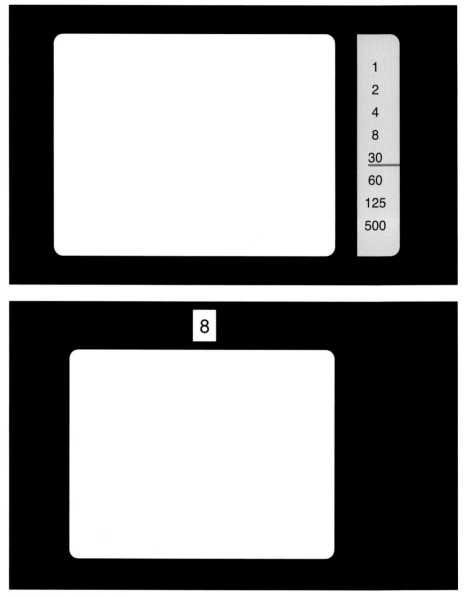

1. Find the light meter

Aperture priority users will see a needle, a series of numbers or both next to the screen in the viewfinder (top). On some models, the correct exposure is illuminated. On others a needle moves up and down, constantly pointing to the correct exposure for an 18 percent gray image in the specific lighting situation.

Shutter priority users will find a small window showing one or more f-stop numbers (above). If more than one number appears, a needle or a light will indicate the correct exposure.

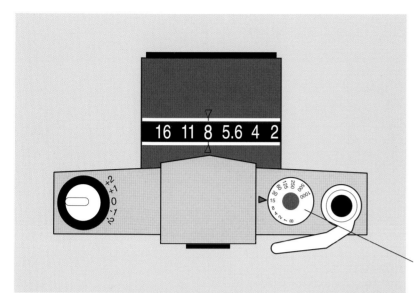

2. Set the exposure

To set the exposure on an aperture priority, find the camera's suggested shutter speed when the aperture ring is set at f8 and the viewfinder is filled with the gray card. Write the shutter speed down for future reference.

To set the exposure on a shutter priority, look for the list of shutter speeds between one second and ⅟₅₀₀ second. Set the dial for 15. This means the film will be exposed to light for ⅟₁₅ second. Keeping the viewfinder filled with the gray card, write down the camera's suggested aperture setting. If an aperture value is not displayed anywhere, follow the instructions for fully automatic cameras on pages 68 to 73.

shutter speed dial

3. The light meter reading may change

Upon returning the camera to its support, you may notice that the setting has changed from the one you wrote down. Because you moved the camera from its view of the gray card, the automatic function has reassessed the lighting situation. Now that the viewfinder at left isn't filled with the gray card, the reading has changed to 125. As long as your lights and the rest of your setup stay the same, though, the reading you took from the gray card will always be the correct one. If your reading has changed, return the setting to the gray card reading you wrote down by adjusting the exposure compensation dial or film speed dial (see page 66). Each time you change the artwork, make sure you return the setting to match the gray card reading you wrote down. When photographing three-dimensional artwork, you'll have to take a new gray card reading each time you move the artwork or lamps.

Using an aperture or shutter priority automatic

4. Fix the meter with the exposure compensation dial

If your camera has an exposure compensation dial, return the meter to the gray card reading by shifting the required number of increments. Some cameras may have an exposure lock or memory lock function. If so, simply take a reading directly from the gray card, lock the exposure for the rest of the session and start taking pictures. Consult your instruction manual to determine whether this feature is available on your camera.

Focus following the directions on page 62 and take a photograph. If your camera doesn't accept a cable release, select the time delay function to avoid camera shake. The camera will take the shot a few seconds after you press the shutter release button. Bracket if you wish following the directions on page 63.

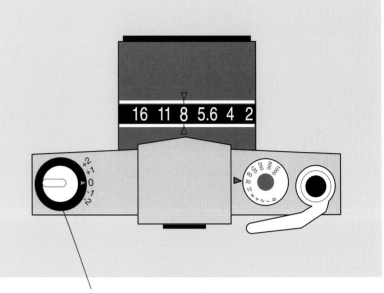

exposure compensation dial

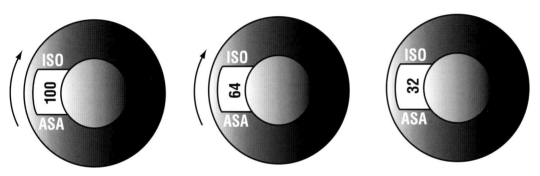

5 Or fix the meter with the film speed dial

If your camera doesn't have a lock function or an exposure compensation dial, locate the film speed dial. adjust the dial until the exposure value shown in the viewfinder matches the value in your note pad.

Focus following the directions on page 62 and take a photograph. If your camera doesn't accept a cable release, select the time delay function to avoid camera shake. The camera will take the shot a few seconds after you press the shutter release button. Bracket if you wish following the directions on page 63.

High-speed film delivers poor reproductions

If you're using the film speed dial to return to the gray card reading, you may find that the dial doesn't have enough increments to adjust as much as you need to. If so, change to a faster film. If you've been using 64, change to 100 or 200, for example. As you move to faster films, you may notice a slight loss of sharpness in your photos, so move up to faster films only as much as necessary. Never go beyond 400. Film this fast is unsuitable for quality artwork photography. You can see the difference between these photographs. The art above was shot with 800 film. The top image was shot with 64 film.

Obstruction
Roger Saddington
Acrylic on board
17½" × 53" (45cm × 135cm)

Using a fully automatic camera

To get accurate photographs with a fully automatic camera, you'll have to study the tonal range of your artwork yourself. After you've learned to anticipate how the camera will expose different artworks automatically, you can set the camera manually to capture the artwork accurately. Compare the lightness or darkness of your artwork to the tone of the gray card.

Try to visualize the mixture of tones and average them. For example, a painting of a white rabbit running across the snow would be much lighter than the gray card. If you were to add a black car that would take up about half the scene, the average tone of the painting would be much closer to that of the gray card. Similarly, a black crow flying at night would form an extremely dark painting, but adding a large white ghost would tilt the balance back toward the value of the gray card. The following six pages will teach you to find the average tone of each artwork and how to adjust the camera accordingly to get the best photograph. If your automatic camera has a manual setting, switch to this setting and follow the directions on pages 60 to 63.

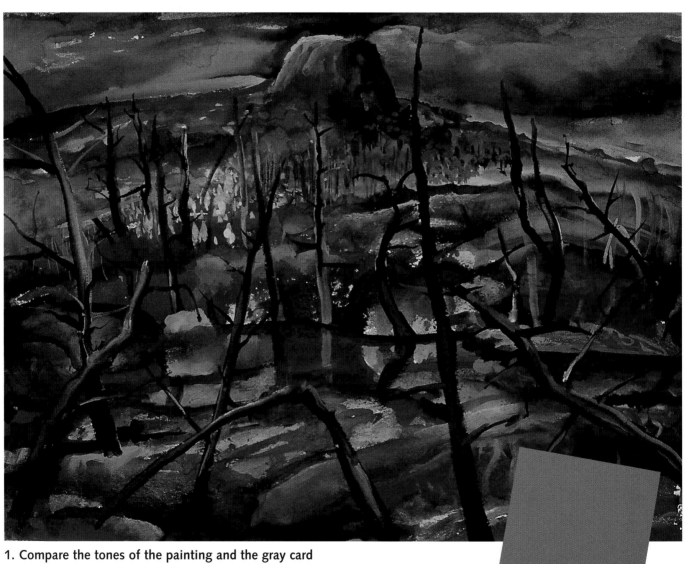

1. Compare the tones of the painting and the gray card
Your choices won't always be clear-cut, but the closer the artwork's average tone is to the gray card's tone, the more likely your shot will be correct without having to change any settings. Place the card directly on the artwork's surface for comparison. The painting above is darker than the gray card; the painting at top on page 69 is lighter than the gray card; and the painting at bottom on page 69 matches the gray card.

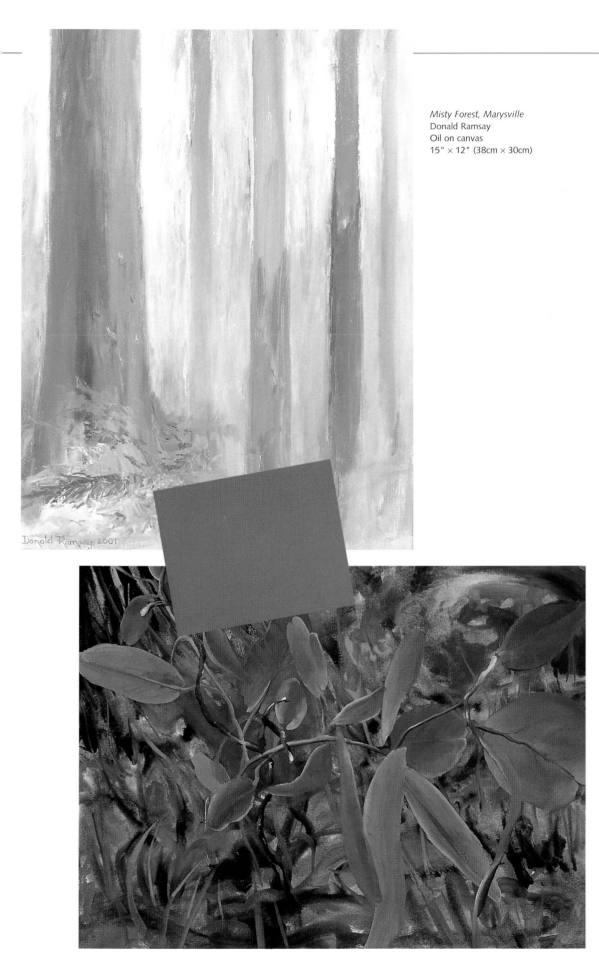

Misty Forest, Marysville
Donald Ramsay
Oil on canvas
15" × 12" (38cm × 30cm)

Sapling
Roger Saddington
Gouache
8" × 12" (20cm × 30cm)

Using a fully automatic camera

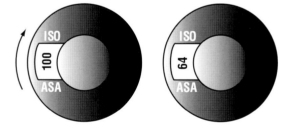

3. Set the film speed dial
Once you've determined the average tonal value of an artwork, set the film speed dial to match the film you've loaded into the camera, then move it up or down according to the following examples. Simply decide whether each artwork is moderately or significantly darker or lighter than the gray card and adjust the film speed dial accordingly. Always start with the film speed dial set for the film you're using.

2. Average the artwork's tonal values
If the comparison isn't obvious, assign tonal values to the picture's main elements. Are they lighter or darker than the gray card? Hold the card next to these elements to help you decide. Create a mental average of the tones. You may have a harbor scene like this one, in which the water and the main ship take up 50 percent of the scene. These objects are a bit lighter than the gray card. Another 40 percent of the painting is bright sky and 10 percent is made up of darker boats. The lighter elements of sea and sky predominate, tipping the balance toward the lighter end of the scale, well above the gray card. The dark boats tip the balance back again, but their influence is not as strong since they take up such a small amount of the scene. Weighing these factors, this scene is moderately lighter than the gray card. You don't have to be mathematically precise. Just make a general estimate, identifying the major elements and their effect on the scene.

The Aurora Australis in Dock—Hobart, Tasmania
Helene Seymour
Oil on board
24" × 30" (61cm × 76cm)

If the painting is moderately lighter
Move the film speed dial to the next lower number (for example, from 100 to 64).

The Run
Helene Seymour
Oil on canvas
26" × 27½" (66cm × 70cm)

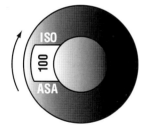

If the painting is about the same

Leave the film speed dial where it is.

Yellow Roses
Helene Seymour
Oil on canvas
17¾" × 13¾" (45cm × 35cm)

If the painting is significantly lighter

Move the film speed dial down two increments (for example, from 100 to 64 to 32). If you're using film that is slower than 100 (for example., 64), your dial may not have enough increments. If so, change to 100 or 200 film.

Using a fully automatic camera

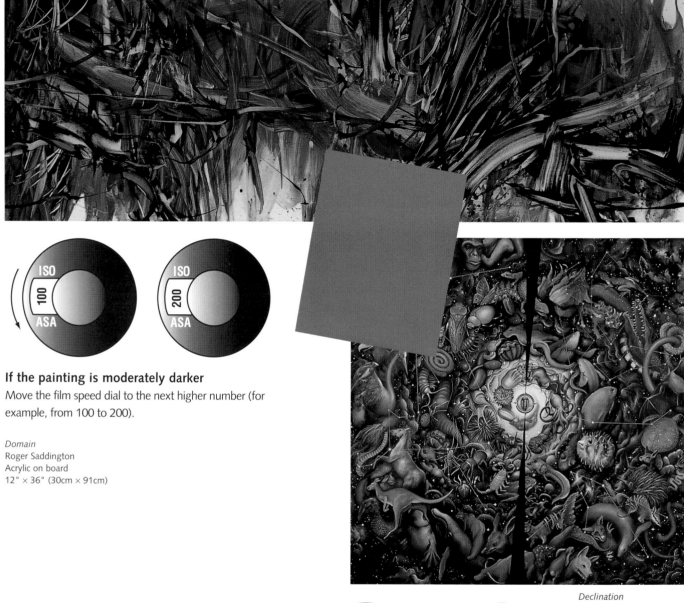

If the painting is moderately darker
Move the film speed dial to the next higher number (for example, from 100 to 200).

Domain
Roger Saddington
Acrylic on board
12" × 36" (30cm × 91cm)

Declination
Roger Saddington
Oil on canvas
36" x 36" (91cm x 91cm)

If the painting is significantly darker
Move the film speed dial up two increments (for example, from 100 to 200 to 400).

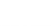

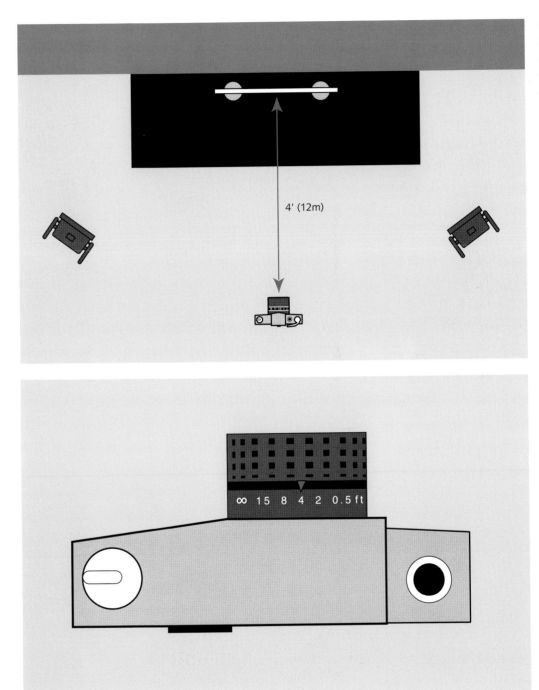

4' (12m)

∞ 15 8 4 2 0.5 ft

4. Focus

Once you've set the film speed dial, focus following the directions on page 62. You may have to focus by estimating the distance from the camera to the artwork (left) and setting the focus ring to match that distance (below).

Take a photograph and then bracket if you wish following the directions on page 63. If your camera doesn't accept a cable release, use the time delay function to avoid camera shake. The camera will take the shot a few seconds after you press the shutter release button.

Troubleshooting

Your photographs should have crisp white highlights and plenty of detail in shadow areas. Make sure that detail in the lightest tones of the artwork is apparent and that darker tones haven't lost detail or filled in toward solid black. Passages of white are useful for checking the quality of your photographs. White areas have no color casts. If your artwork doesn't have substantial areas of white to check, include a sheet of white paper in a test shot for your first few shoots to make sure you're on the right track. Do your photos capture your artwork accurately? If not, use the troubleshooting tips in this chapter to identify and remedy problems. If you're happy with your results, keep evaluating future photos. You still may discover room for improvement.

In this chapter you'll also find advice for photographing artwork with metallic paint and artwork hanging in galleries or exhibitions. The key to photographing metallic paint is to let light reflect off the metallic parts without making the rest of the painting look washed out. You can't control the light in galleries and exhibitions, so you'll have to identify what light is present and compensate for it with filters.

Examining your photos

Look through this chapter to identify common pitfalls in artwork photography. Once you've recognized the problem, you'll find tips to improve your technique. If you've lost detail in highlight or shadow areas or if you think all of the images are either too light or too dark, you'll need to take more photographs.

Also try to determine how people will be viewing your work. Slides that will be viewed on a projector could look better up to a full stop darker than those viewed against a window or light fixture. Adjust the dial just a half stop to get a slide acceptable for both a slide projector and a window. If you own or can borrow a slide projector, try your slides out by projecting them. Follow the directions for each kind of camera to adjust the exposure.

If you see color casts in your shots, carefully examine your workstation for ambient light. Small amounts of daylight, moonlight, fluorescent light or street light all can cause color shifts when you're photographing under tungsten light. Turn off all of your halogen lamps and then check for and eliminate all other light sources.

Evaluating photos
Look at your slides using a loupe and a light box, slide projector or window. If your prints aren't accurate, look closely at your negatives to see if the problem occurred during the photo shoot rather than during the film processing stage.

Check for these lights before each shoot to be sure. Also remember that as lamps age, they may start to emit warmer or more yellow light, so you may want to replace your bulbs every so often.

If you're shooting prints instead of slides and none of the photography pitfalls seems to be the problem, the error probably occurred during the printing stage. Use the examples in this chapter to identify the problem so you can explain it to your printer in your own words.

Color casts on slides

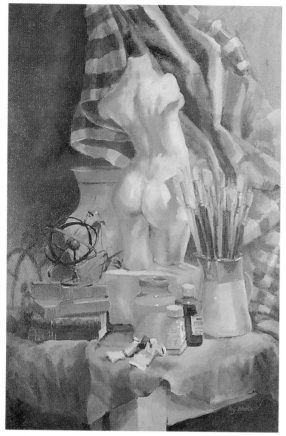

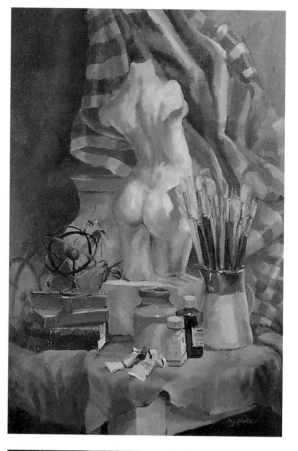

Yellow-orange color cast
Don't use daylight slide film under tungsten light.

Blue color cast
Never use an 80B blue filter with tungsten-balanced film.

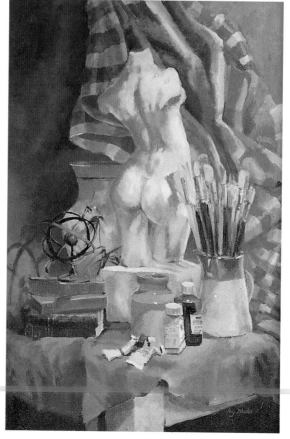

Blue or orange color cast
Never photograph artwork in daylight.

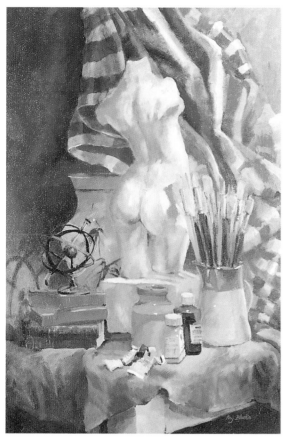

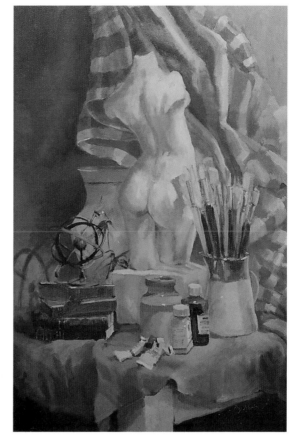

Color cast
Use only tungsten-halogen lamps, and eliminate all other light sources.

Too light
For correct exposure, remember to switch off the house lights.

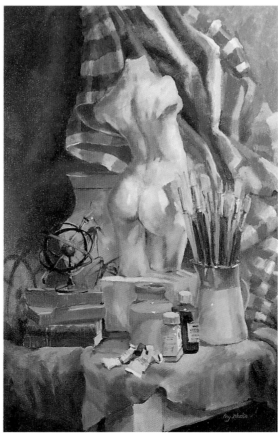

Correct lighting
Simple mistakes at the shooting stage, such as those mentioned on these pages, can spoil your results. This photo was shot under correct lighting.

Studio Blues
Kay Blackie
Oil on canvas
30" × 20" (76cm × 51cm)

Color casts on prints

Yellow-orange color cast

Always attach an 80B blue filter when using negative film under tungsten light.

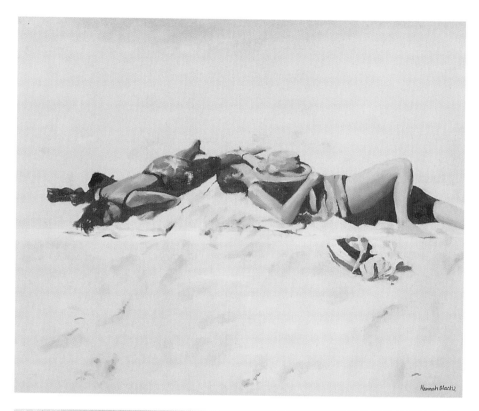

Correct print

This image was taken using a filter on daylight film, the correct way to compensate for tungsten light's yellow-orange color when shooting prints.

Summertime Siesta
Hannah Blackie
Oil on canvas
18" × 26" (46cm × 66cm)

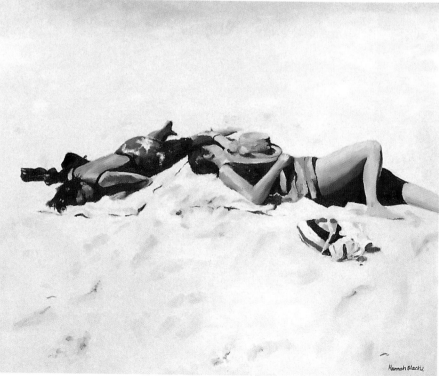

Poor framing

Edge out of shot
Check the viewfinder. Always allow a gap between the
artwork edge and the viewfinder frame.

Correct framing
The photographer didn't leave a gap between
the artwork and the viewfinder edge in the
image above left. The image at left is the
result when the correct gap is allowed.

The Conductor
Kay Blackie
Oil on canvas
14" × 11½" (36cm × 29cm)

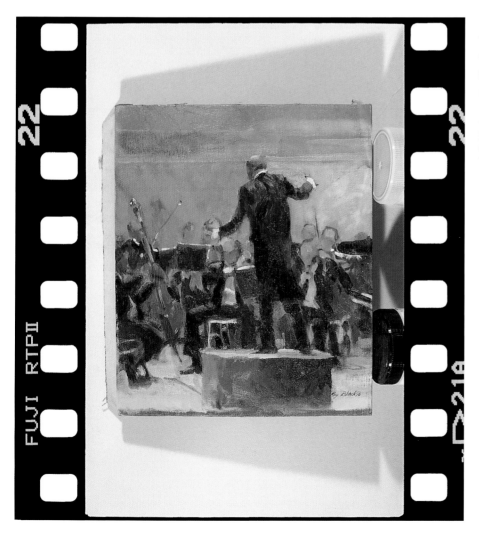

Poor framing

Check camera's position

Make sure the line from the lens barrel is perpendicular to the artwork's surface.

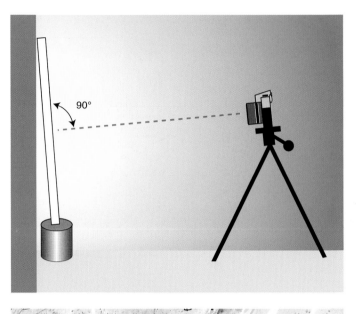

Distorted edge

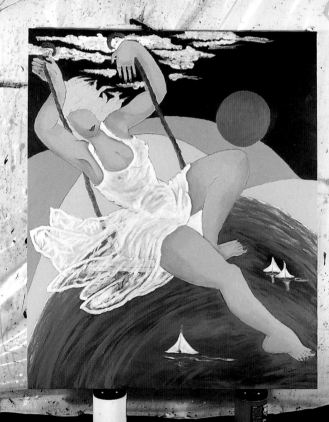

Correct framing

Swing with Skyhooks
Bibi Ostermark
Acrylic on canvas
36" × 30" (91cm × 76cm)

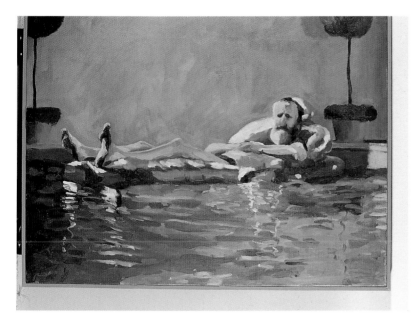

Artwork positioned incorrectly within viewfinder

When photographing small to medium artwork with a compact camera, use the parallax marker as your viewfinder frame.

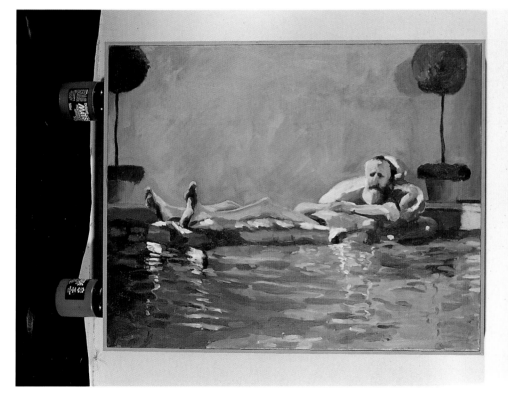

Correct framing

This image was centered within the camera's viewfinder.

Dad
Hannah Blackie
Oil on canvas
27½" × 35½" (70cm × 90cm)

Out of focus

Poor focus
Use well-defined lines in the art-
work to focus accurately.

Split-screen focusing
Use the split-screen device in the viewfinder
for best results. The image at top is not
focused correctly. The viewfinder above
shows correct focusing.

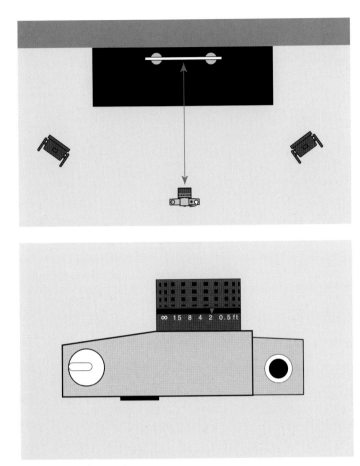

Measuring focus distance

If your camera doesn't have a split-screen focusing device, measure the exact distance from the camera to the artwork and set the focus ring to match.

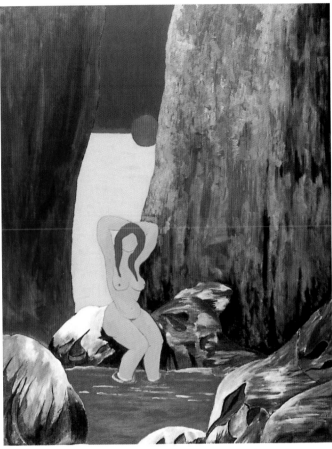

Accurate focus

Redhead on Rocks
Bibi Ostermark
Acrylic on canvas
40" × 30" (102cm × 76cm)

Camera shake

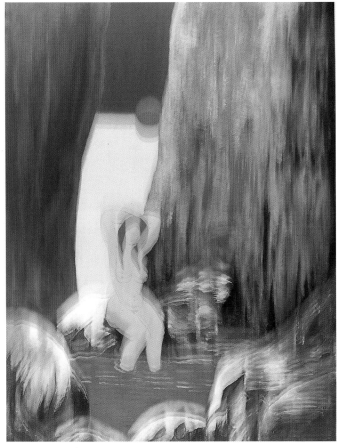

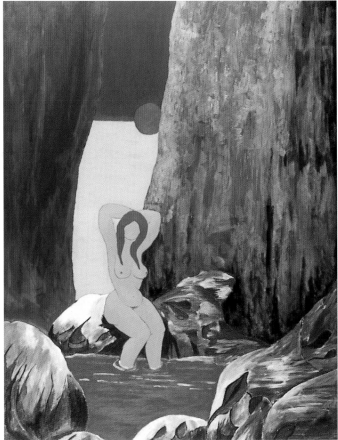

Movement during exposure
Keep the camera absolutely still when shooting. Try using a cable release or the time delay function.

Steady camera

Reflections or glare

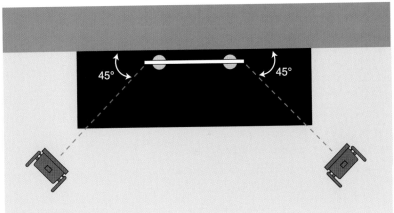

Light reflecting into lens

Make sure each lamp is positioned at a 45-degree or smaller angle from the wall.

Correct lamp position

The lamps were arranged so less light reflects off the painting into the lens for this photo.

Blue Pots
Kay Blackie
Oil on canvas
16" × 14" (41cm × 36cm)

Flash flare

Light source too close to camera
Don't use a camera-mounted or built-in flash. Position at least one light on either side of the artwork.

Correct lighting

Waiting for My Ship to Come In
Bibi Ostermark
Pastel on paper
18" × 12" (46cm × 30cm)

Glass reflections

Standard lighting setup

If you're photographing artwork covered by glass, eliminate most reflections by adjusting the placement of your lamps. Remove persistent reflections by covering objects in front of the artwork, including even the camera and yourself, with black cloth. The most convenient arrangement is to hang a black curtain between the camera and the artwork, leaving a small hole in the curtain for the lens. Of course, removing the glass from the painting is the ideal solution.

Black cloth added

This shot was taken with black cloth covering objects that might reflect light onto the glass covering the painting.

Leda
Bibi Ostermark
Pastel on paper
12" × 16" (30cm × 41cm)

Color patches

Light leaks

Never expose the film to light except at the moment of exposure. If you often experience this problem, have your camera housing checked for leaks.

Correct exposure

Incorrect exposure

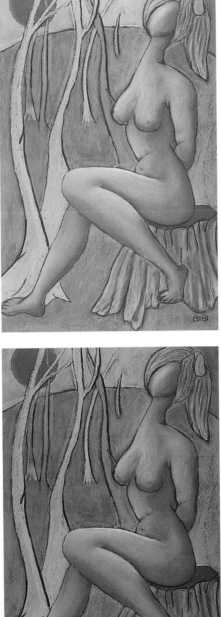

Too dark or light

If all of your shots are too dark (far left), adjust your standard exposure to a smaller f-stop number (for example, f5.6 to f4). Don't let the aperture numbering system confuse you; a move from f5.6 to f4 would actually make the aperture larger so it will let in more light. Owners of automatic cameras should move the film speed dial or exposure compensation dial down one increment (for example, from 100 to 64).

If all of your shots are too light (near left), adjust your standard exposure to a larger f-stop number (for example, f5.6 to f8). This adjustment will make the aperture smaller, letting in less light. Owners of automatic cameras should move the film speed dial or exposure compensation dial up one increment (for example, from 100 to 200).

Correct exposure

Mother's Day
Bibi Ostermark
Pastel on paper
18" × 12" (46cm × 30cm)

Correct exposure

Lady of the Forest
Bibi Ostermark
Pastel on paper
18" × 12" (46cm × 30cm)

Damaged film

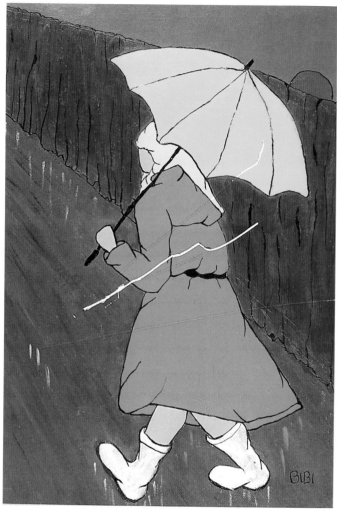

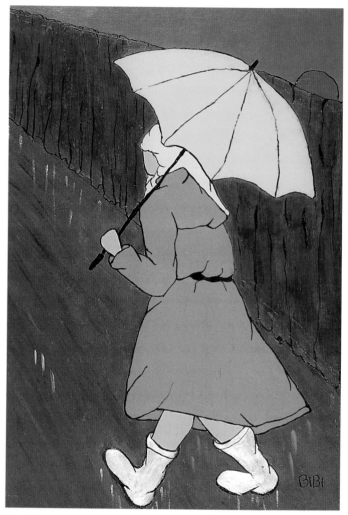

Scratched slide

Always handle slides and negatives carefully. If the lab scratches your film during processing, you may be able to get a replacement roll, so inspect your film carefully before leaving the lab. Scratches can be removed by expensive digital retouching if necessary.

Scratch removed

Rain
Bibi Ostermark
Acrylic on paper
18" × 12" (46cm × 30cm)

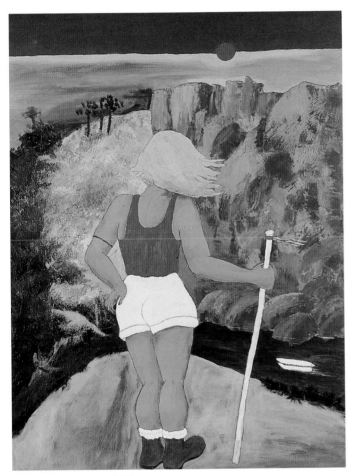

Old, poorly stored film

Don't use film that is too old, has been exposed to heat or has been left too long between shooting and processing.

New film processed promptly

Gorge-ous
Bibi Ostermark
Acrylic on canvas
14" × 11½" (36cm × 29cm)

Poorly cropped print

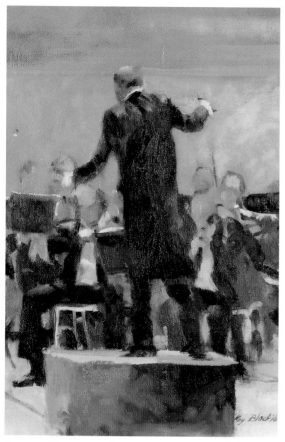

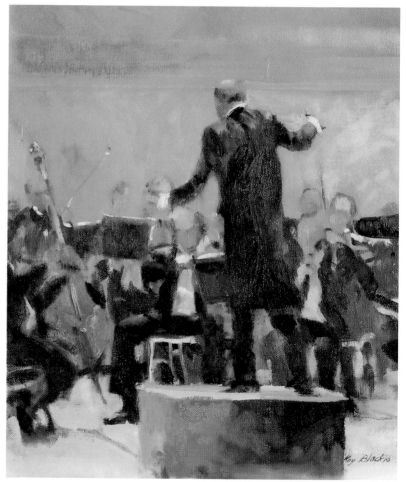

Incorrectly cropped print

Processing labs sometimes crop carelessly during the printing stage, eliminating too much of the image. Check your negative to make sure you allowed enough room around the artwork when taking the photograph before complaining to the printer.

Correct gap allowed

Too much contrast on print

High contrast
Some minilabs develop prints with too much contrast. If this happens, take your film to a pro lab for processing.

Correct print

Crash
Roger Saddington
Acrylic on board
31½" × 47¼" (80cm × 120cm)

Use your own words

Before approaching the printer, make sure the problem with your prints did not occur during your photo shoot. If you think the problem occurred during the printing stage, use your own words to describe what is wrong with your photo. This will give the technician a better idea of what the print should look like.

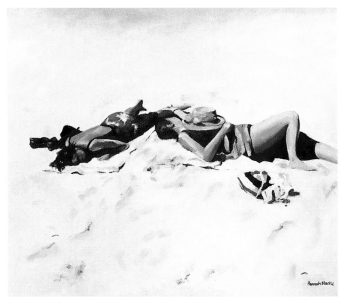

Too dark

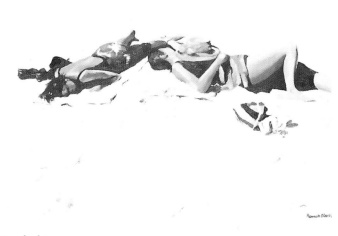

Too light

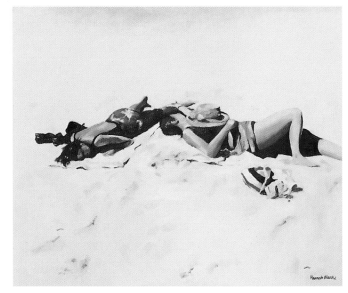

Too red

Too blue

Too yellow

Too light and too blue

Too dark and too yellow

Correct print

Photographing metallic paint

Accurately photographing the texture of two-dimensional artwork with metallic surfaces, such as gold paint or gold leaf, is a constant thorn in photographers' sides, even for professional museum photographers. These surfaces tend to look flat and monochromatic on film. The paint looks more like a dull, light brown than a lively metallic sheen. The solution is simple but does require a bit of creativity and some careful adjustment to the process you've learned.

First, get another halogen lamp. If you're using two lamps for your standard setup, buy a third. If you're using four lamps, buy a fifth. If possible, buy a lamp of lesser strength than the ones you're already using.

Set up your workstation and lamps as you normally would for two-dimensional artwork. To photograph regular paintings, you learned to keep light from reflecting from the artwork into the lens, but now you'll do the opposite. Position the extra lamp somewhere between the other lamps so its beam reflects off the metallic surface into the camera lens. The closer the extra lamp is to the camera, the closer the highlight will be to the center of the artwork. To prevent the entire image from being washed out by flare, make sure the amount of light reaching the artwork from the extra lamp is significantly less than the light from the other lamps.

Once you've set up the extra lamp, you'll have to experiment to get the best results. Move the lamp from side to side, up and down, and back and forth to observe the effects on the metallic appearance of the artwork. Also observe the effect of flare on the nonmetallic areas. You may have to compromise between a good metallic effect and an accurate rendering of other surfaces.

The extra lamp will affect the total amount of light striking the artwork's surface, so after finalizing your new setup, take a new gray card light reading. Do this each time you reposition the extra lamp.

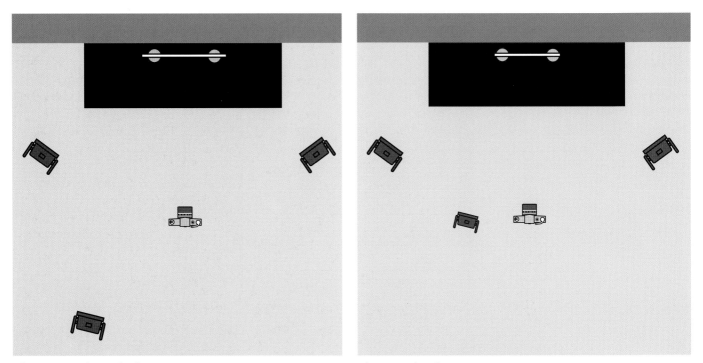

Place strong lamp farther away
If your extra lamp is the same strength as your standard lamps, move the extra lamp twice as far from the artwork as the regular lamps to lessen its effect on the artwork.

Place weaker lamp next to camera
If your extra lamp is weaker than your standard lamps, position it the same distance or just slightly farther away from the subject.

Extra lamp added

The photograph on the left was taken with the standard setup. The image on the right was taken with an extra lamp positioned to highlight the metallic surface.

The Archangel Gabriel
Dr Ursula Betka
Tempera and gold leaf on panel
8½" × 7½" (22cm × 19cm)
Prototype: Cypro-Cretan icon, sixteenth century,
 Monastery of Ayios Neophytos, Cyprus
32½" × 27½" (83cm × 70cm)

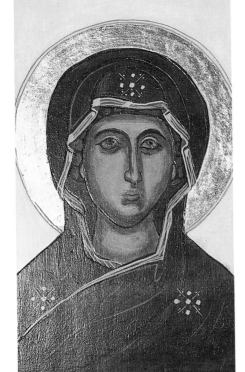

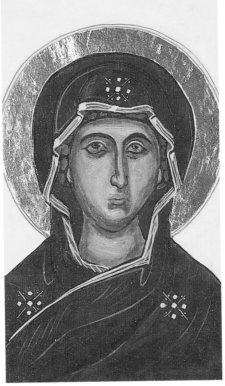

Avoid flare

Glossy, nonmetallic surfaces shouldn't reflect light from the extra lamp into the lens, as in the image at far left. Experiment so that you illuminate the metallic areas without causing flare on others as in the image near left.

The Virgin Mary, Theotokos
Dr. Ursula Betka
Tempera and gold leaf on panel
8½" × 5½" (22cm × 14cm)
Prototype: Cretan icon, sixteenth Century
13" × 10½" (32cm × 27cm)

Photographing galleries in daylight

Uncontrollable color casts or the unavoidable presence of more than one light source can make photographing art in galleries or exhibitions difficult if you don't know what you're dealing with. Before taking a photograph, identify the kinds of light present and determine how to correct for these light sources with filters.

Attach the filter to the lens before taking a light reading with a gray card. Otherwise, the reading won't be correct for that filter. Remember to take a new light reading each time you change the filter or revert to unfiltered shots.

Daylight is a common component in gallery lighting and often is accompanied by another light source, such as tungsten or fluorescent light. Identify any additional light sources and their effects on the artwork.

81B filter
Daylight tends to take on a blue tinge indoors, outdoors on cloudy days and in shadows. Correct this with an 81B filter, also known as a warm-up filter.

Juncture
Roger Saddington
Acrylic on board
23½" × 47¼" (60cm × 120cm)

Make sure you need a filter
If the effects of light sources other than daylight are small, the difference may not be noticeable and you may not need a filter. This is especially true if you're indoors with a very small amount of tungsten light. The warm-colored tungsten compensates for the bluish tinge normally found indoors under natural light, producing a similar effect to the 81B filter. The photograph above was taken indoors with just a bit of tungsten light and without a filter.

DEFINITIONS

81B filter—also known as a warm-up filter, a filter that corrects for daylight

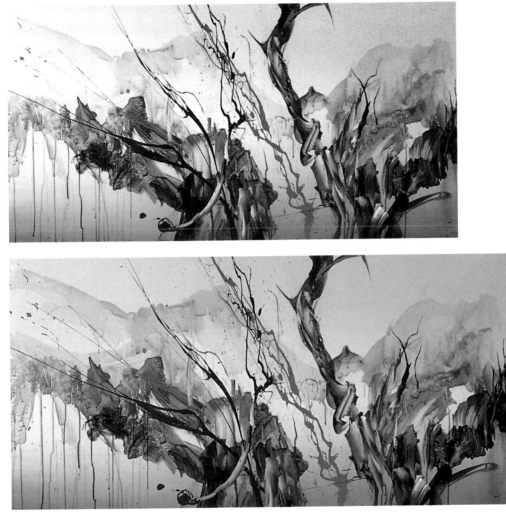

Filter daylight with an 81B filter

The image at top was shot in unfiltered daylight. The image above was shot in daylight with an 81B filter.

Photographing galleries in tungsten light

Most galleries use tungsten spotlights, the same light you've set up in your own studio. Also check for small amounts of daylight from other rooms, small windows or skylights.

80B blue filter

Use an 80B blue filter to correct tungsten light on daylight film, just as in your own studio.

Filter tungsten light with an 80B blue filter

The scene above was shot under tungsten light. The scene at right was shot under the same light with an 80B blue filter.

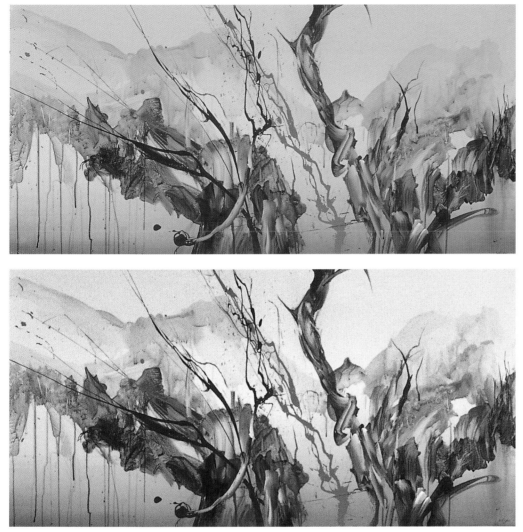

Combine filters

If tungsten lighting and some daylight are present, use the 80B blue and 81B filters together. The image at top was shot under tungsten lighting with some daylight present. The image above was shot under the same conditions with both filters.

Photographing galleries in fluorescent light

Galleries may use fluorescent lighting alone or with daylight. Carefully check for other light sources before shooting. Filtering fluorescent light produces less predictable results than filtering tungsten light. When you do get positive results, they sometimes are only marginally better than unfiltered shots. Different fluorescent lights vary in color a great deal, and no particular filter can correct each one satisfactorily.

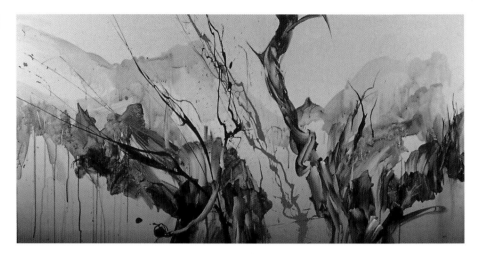

FL-W filter
Use this strong fluorescent filter to correct fluorescent lighting. If it makes the artwork appear too blue, use it with the 81B filter.

DEFINITION

FL-W filter—also known as a strong fluorescent filter, a filter that corrects for fluorescent lighting

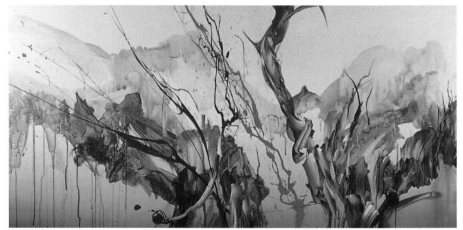

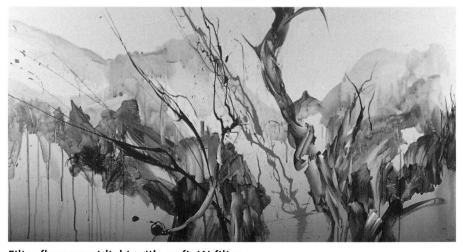

Filter fluorescent light with an fL-W filter
The image at top was shot in unfiltered fluorescent light. The image in the middle was shot with an FL-W filter. The image above was shot with FL-W and 81B filters.

FL-DAY filter

This weak fluorescent filter has a lesser effect than an FL-W filter. Use it to correct small amounts of fluorescent lights present along with daylight.

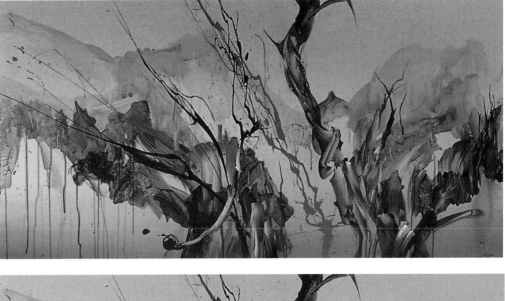

DEFINITION

FL-DAY filter—also known as a weak fluorescent filter, a filter that corrects for small amounts of fluorescent light present in daylight

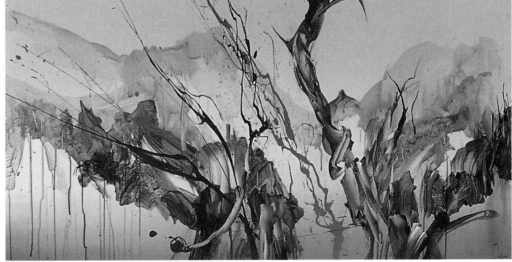

Filter small amounts of fluorescent light with an FL-DAY filter
The image at top was shot in daylight with minimal fluorescent light present. The image above was shot under the same conditions with an FL-DAY filter.

Experimenting with filters

You can combine the filters discussed on the previous pages in many ways. Here are some more ways to manipulate tungsten and fluorescent light. In most cases, warmer shots are the most pleasing. Experiment with different filters and choose the best slides for your own purposes, whether you need the most accurate or most pleasing shots.

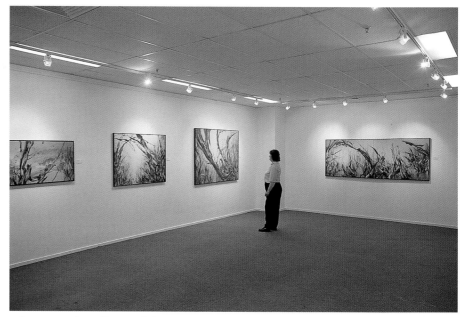

Observing the effects of filters
This image was shot under tungsten and fluorescent light. Observe the differences in the following pictures using different filters.

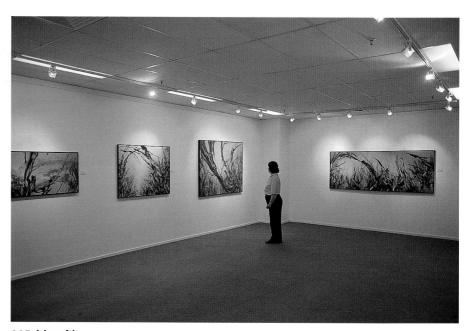

80B blue filter
This image was shot with an 80B blue filter.

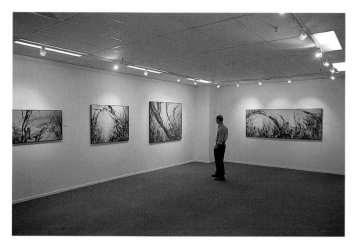

FL-DAY filter

This image was shot with an FL-DAY filter.

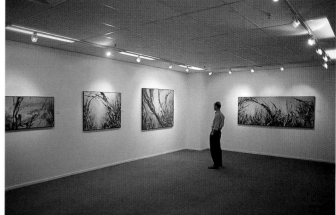

FL-DAY and 80B blue filters

This image was shot with FL-DAY and 80B blue filters.

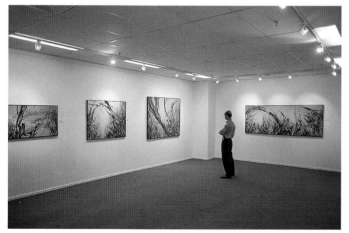

FL-W filter

This image was shot with an FL-W filter.

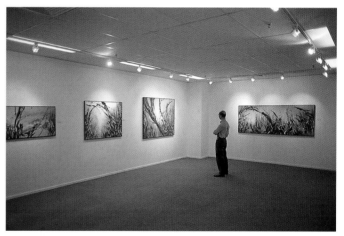

FL-W and 80B blue filters

This image was shot with FL-W and 80B blue filters.

Conclusion

The camera doesn't quite tell the truth in photography. Once you start getting the best possible results, you'll realize you have to accept some small inaccuracies. For example, color film can't render certain colors exactly, and certain film brands cope better with certain colors. A film that works best for all colors just doesn't exist. Photography can only mimic the colors of real-life pigments.

These faults are not huge obstacles, but they do deserve mentioning for the sake of the artists who will encounter them. They are most apparent in photographs of artwork with pure pigments of high tints, such as Phthalocyanine, Cadmium and Viridian colors. You can correct the photograph in every other respect—exposure, tonal range, detail and even general color balance—but the specific pure colors simply might appear slightly off.

Don't panic if this happens. If you're working on an important set of shots that must be right—for reproduction in a book or magazine, for example—or if you use problem colors frequently, try other brands of film. You may find a certain brand particularly suited to the unique demands of your work whether in color, tonal range or contrast.

Also realize that images on film can be enlarged only so much without becoming grainy. For important items, such as books and exhibition catalogs, the first priority is to supply photographic material of the highest quality. Publishers and printers want slides or larger transparencies instead of prints or negatives. Make sure your slides are sharp, correctly exposed originals. If you want to reproduce your artwork larger than 8" × 10" (20cm × 25cm), have a professional photographer shoot medium- or large-format transparencies.

Photography is not a perfect art, just as brushes and paints aren't perfect tools. Over time, though, you'll learn how to get the best possible results that communicate what you want to get across with your art and photography.

Glossary

ambient lighting—extra light, such as the daylight streaming in from a window

aperture ring—the ring that allows you to control the size of the opening that allows light in to the film

automatic camera—a camera that chooses settings, such as the size of the aperture and the shutter speed, on its own

bracket—to take a few photographs of the same image at different exposures to guarantee that you get one that matches your artwork

cable release—a cable that allows the photographer to release the shutter and take a picture without touching and thus perhaps moving the camera

camera shake—movement of the camera at the moment you're exposing the film, which results in a blurry photo

compact camera—the average snapshot-camera that, unlike a single-lens reflex, has two lenses, one for the viewfinder and one for the film. Most compacts are automatic.

contact sheet—also known as an auto proof, one sheet of photographic paper that shows all of the photographs from a roll of film

digital camera—a camera that records digital images rather than capturing images on film

dpi—dots per inch, a measure of digital resolution

18 percent gray—a uniform standard, based on the average tonal value of most photography scenes, for measuring light levels

80B blue filter—a filter for the camera lens, used with daylight film, that compensates for tungsten light's yellow-orange color

81B filter—also known as a warm-up filter, a filter that corrects for daylight

50mm lens—the standard lens that will allow you to focus accurately on your artwork

film speed dial—also known as the ASA/ISO dial, a dial that indicates what speed film is in the camera

flare—the result in a photograph when light from the light source reflects off the subject into the camera lens

flash—a light source that emits a neutral color, though it doesn't shine long enough for the photographer to determine if it's shining evenly and in the right direction

FL-DAY filter—also known as a weak fluorescent filter, a filter that corrects for small amounts of fluorescent light present in daylight

FL-W filter—also known as a strong fluorescent filter, a filter that corrects for fluorescent lighting

f-stop—a degree of measurement on the aperture ring

gray card—a card made up of the standard 18 percent gray color

light box—any device that projects light through a translucent surface so you can view film

loupe—a kind of magnifying glass for viewing slides or film

manual camera—a camera that allows the photographer to control the settings

negative film—the film photographers use to produce prints

ppi—pixels per inch, a measure of digital resolution

print—a photograph printed on photographic paper like a normal snapshot as opposed to a transparent slide

resolution—the accuracy of a digital image. A digital camera capable of a low resolution will produce a digitized image in which you can see the dots of color that make up the image. High-resolution images look more realistic.

shutter speed—the amount of time the shutter stays open to allow light to hit the film

single-lens reflex—a camera with one lens through which the photographer looks at the image and takes the picture. Other cameras have a viewfinder separate from the lens so the photographer views the scene from a slightly different perspective than the film views it.

slide file—plastic sheet that holds several slides for storage in a binder or filing cabinet

slide mount—a small plastic or paper frame that protects a slide and makes it easier to handle

support—any item, including a tripod, that will balance a camera at the right height and angle

35mm—the size of slide and negative film

TTL—light meter built into the camera

Index

Contributors

Dr. Ursula Betka

Dr. Ursula Betka is a medieval art historian and practicing artist who works with egg tempera on wood panel with decorative gold leaf and draws inspiration from the related traditions of Eastern icons and Italian medieval panel-painting. She teaches art history at the University of Melbourne and Council of Adult Education and also conducts art classes in egg tempera and icon painting. Her doctoral research involved the study of fourteenth century Italian icons and illuminated music manuscripts associated with the laude-singing lay confraternities–the Laudesi–in Florence and Siena. As both an artist and historian she continues to explore the relationship between images and sung prayer, and the interface between eastern and western cultures.

Hannah Blackie

Hannah Blackie was born in Melbourne, Australia, in 1970. She studied graphic design at Monash University. Hannah currently works in her own graphic design business, but her first love is painting and drawing.

Kay Blackie

Kay Blackie was born in Melbourne, Australia, in 1945. She currently lives and works in Hampton, Australia, where she teaches painting at the Blackie Realist Art School, established in 1975. She has won many awards, as have her students.

Bibi Ostermark

Bibi Ostermark was born in Copenhagen, Denmark, and immigrated to Australia in 1974. She blends the experience of two cultures in her work. A keen observer, Bibi attempts to capture the idiosyncrasies of life and its players through body language instead of detailed facial expressions. Her ideas are drawn from everyday life events, emotions and those moments when life comes close to fantasy. Filled with strong shapes and intense color, many of Bibi's works encourage viewer interaction through humor and conceptual content. She exhibits regularly.

Donald Ramsay

Donald Ramsay is a contemporary painter who draws inspiration from the Australian wilderness, the outback and the ocean. He was born in Melbourne, Australia, and has held many solo exhibitions around Australia. His paintings have received numerous awards, and he is represented in private and corporate collections around the world.

Helene Seymour, V.A.S.

Born in Cornwall, England, in 1942, Helene Seymour was transfixed by the movement of animals, particularly horses, from an early age. By the time she moved to Australia at the age of six, she was continually drawing. After the birth of her fourth child, she painted in oils and acrylics and exhibited regularly. No longer satisfied with the demand for "popular" works, Helene has allowed her recent work to rely on intuition, spontaneity, design and the quality of paint itself, sometimes leading to abstraction. Corporate and private collections throughout the world represent her work, and she has received more than twenty-five major art awards.

Rynne Tanton

Rynne Tanton is one of Australia's most prominent ceramicists. Over a period of more than thirty years, the Tasmanian-based potter has been involved in research and exploration of the medium. Formerly head of the University of Tasmania School of Art, he runs his own pottery studio, Crickhollow Pottery, and frequently holds workshops and demonstrations. He has received numerous awards and has held ten solo exhibitions and many group exhibitions in Australia, United States, Canada and Japan.

Look for these other exciting titles from North Light Books!

Create your own artist's journal and capture those fleeting moments of inspiration and beauty! Erin O'Toole's friendly, fun-to-read advice makes getting started easy. You'll learn how to observe and record what you see, compose images that come alive with color and movement, and make a travel kit for creating art anywhere, at any time.

ISBN 1-58180-170-X, hardcover, 128 pages, #31921-K

Mastering basic brushwork is easy with Mark Christopher Weber's step-by-step instructions and big, detailed artwork. See each brushstroke up close, just as it appears on the canvas! You'll learn how to mix and load paint, shape your brush and apply a variety of intriguing strokes in seven easy-to-follow demonstrations.

ISBN 1-58180-168-8, hardcover, 144 pages, #31918-K

Celebrate Your Creative Self can help make your artistic dreams a reality! Dozens of step-by-step mini demos help you to explore and experiment with your favorite medium, whether you're a beginning or advanced artist. You'll learn how to express yourself no matter what unusual approach your creations call for.

ISBN 1-58180-102-5, hardcover, 144 pages, #31790-K

Inside you'll find practical guidelines for depicting the beautiful skin tones of human subjects from across the world. Lessons and demonstrations in oil, pastel and watercolor teach you how to mix colors, work with light and shadow and edit your compositions for glowing portraits you'll be proud of.

Get these and other great North Light titles from your local art & craft retailer, bookstore, online supplier or by calling 1-800-448-0915.

ISBN 1-58180-163-7, hardcover, 128 pages, #31913-K